GARDEN STATE OF DECAY

DISCARDED NEW JERSEY

ALEX GULINO

AMERICA
THROUGH TIME®
ADDING COLOR TO AMERICAN HISTORY

America Through Time is an imprint of Fonthill Media LLC
www.through-time.com
office@through-time.com

Published by Arcadia Publishing by arrangement with Fonthill Media LLC
For all general information, please contact Arcadia Publishing:
Telephone: 843-853-2070
Fax: 843-853-0044
E-mail: sales@arcadiapublishing.com
For customer service and orders:
Toll-Free 1-888-313-2665

www.arcadiapublishing.com

First published 2021

Copyright © Alex Gulino 2021

ISBN 978-1-63499-315-9

Typeset in Trade Gothic
Printed and bound in England

CONTENTS

ACKNOWLEDGMENTS

This book would not be possible without my exploring and photography friends that have helped me so much along the way, namely Mike Carroll, Heather Hacker, Karen Wilson, Alex Codella, Tito Alam and Kim Zier. We have had so many amazing adventures together and those experiences would not be the same without you. I appreciate your sense of adventure and eye for art.

Those closest to me have been my rock. I would be lost without my family: Alberto Gulino, Janice Gulino, and Michael Gulino and family. Thank you to Miriam Cortez for her friendship and guidance in writing, and Ruben Reyes and Victor Gosselin for their love and support. Also, my stepmother, Nancy Alvarez; stepbrother, Paul Urquiaga; and sister-in-law, Rosemarie Araujo, have been so supportive and helpful along my journey and I am incredibly grateful.

The pages I help moderate on Instagram, @northjerseyadventures, @glitz_n_grime, and @urbex_supreme, have proved to be a great influence on my photography journey, and for that I am forever grateful. For all their cheerleading, a sincere thank you to WIRW.

Lastly, I would like to show my appreciation to Jay Slater for initially reaching out to me, Alan Sutton for his guidance, Kena Longabaugh for her assistance, and Fonthill Media for the opportunity.

INTRODUCTION

In writing this second book on abandoned places, it felt quite different for me than my last book. With more experience in both photography and visiting abandoned buildings, I was less focused on getting as many photos as possible and more focused on enjoying the moment and thinking of new perspectives. I am starting to hit my groove. Based on the actions of other explorers, I would consider myself a more conservative explorer. I'm not the one that will climb a ten-foot ladder to enter a place; I'm not the one that will try to sneak into a place in between security shift changes—and that's okay. Having a risky hobby such as this, it's important to be comfortable with what you're doing. If you're uncomfortable with the situation, it may be a sign that this is not the place or the time to go exploring. That gut feeling could be what saves you from injury or worse.

Urban exploration, better known as Urbex, is nothing new. It can be defined as visiting and exploring ruins or abandoned properties, with the primary focus on photographing such decay. To be clear, I do not recommend urbex as a hobby. It can be dangerous and often requires you to enter private property. Property owners do not want you to get injured on their property, nor do they want to see their property destroyed. Most who do urban exploration abide by the rules: no vandalism, leave nothing but footprints, and take nothing but photographs. Aside from that, most urban explorers will not freely give out locations in order to protect them from vandals. I have been vague in my descriptions of locations in this book because of this.

No two abandoned places (aka "bandos") are the same. It's easy to say, "All hotels look the same," but they do not. Some lobbies are intricate with amazing details, some are standard corporate looks. What I attempted to do in this book is to show a variety of places, including some fun roadside finds. Not everything I find is conducive to entering, but still beautiful in its decaying facade. Often, we go right past these structures, ignoring them because they don't fit the status quo. I, however, pull over for them. Why was that barn just left there to decay? How is there a military jet just

sitting in the woods? Why is that huge school sitting there empty? These photos often create more questions than answers, but the mystery sucks me in.

Photographing discarded spaces such as these during a pandemic with stay-at-home orders is a bit of challenge, to put it mildly. At first, no one was going anywhere with anyone. Then others would say it was the best time to be out exploring. This was not the case for me. On a normal day (pre-pandemic), I would load up my car with some friends and off we would go. This was no longer an option now that we had to stay six feet away from others. Living in a world where your community and your friends must stay at a distance fosters an eerie feeling. I suppose that's how we arrive here, with this book. These spaces convey unnatural feelings, yet a very natural curiosity. Join me in my journey through the forgotten, the discarded, and the decay throughout New Jersey, the Garden State.

1

TRENTON SCHOOL

SCHOOL'S OUT FOREVER

Inside New Jersey's capital city, there can be found a decaying school abandoned in 2007. We were fortunate enough to find a way in pretty easily, entering through an old gym where I swear you can still smell the sweat. It's bizarre to see a school in such ruin. A place once filled with such life and activity now sitting there completely still is surreal.

Finding a complete history on this school and its closing is no simple task. Apparently, this property used to contain two schools: an abandoned junior high school and what was once an elementary school. While the elementary school was demolished years ago, the junior high school managed to escape the same fate. Despite being closed in 2007, the school was never completely torn down. It seems that part of this still standing junior high met the wrecking ball, but the job was never finished. I cannot seem to find an answer for this.

Upon entering the school from the gymnasium, we see that many visitors have come before us. There is graffiti, smashed windows, and the familiar crunch beneath my feet. In the distance, we hear other voices. Something I never want to hear in an abandoned place.

We make our way through the debris in the school hallway and enter the auditorium. We discover this is where the voices are coming from. The voices quickly become softer, much to our relief, and we assume it's because they, too, do not know if we have come to cause trouble. We try to move along taking our photos, and most importantly, mind our own business.

We find no typical classroom chairs, but encounter the cafeteria, another gymnasium, and the pool that was installed later on. To think of all the money that has been spent building this place, making additions like a pool, and it all sits here wasting away.

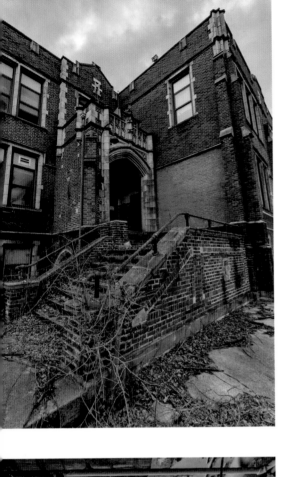

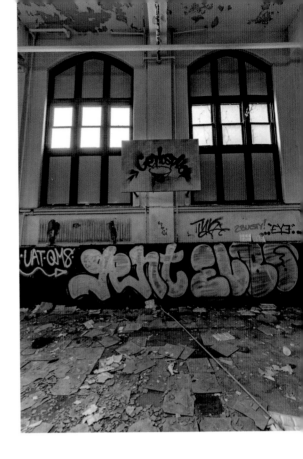

Above left: Nature takes over the school entrance.

Above right: A lonely basketball hoop sits in the silent gymnasium.

Left: Peering down the quiet school hallway.

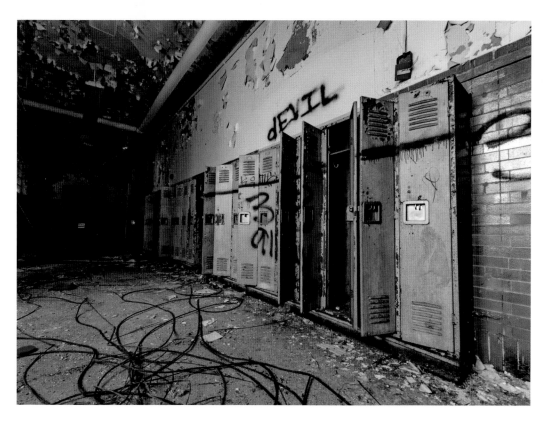

Above: School lockers sit empty.

Right: It seems nearly every window in this school was broken by vandals.

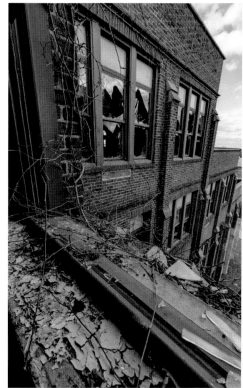

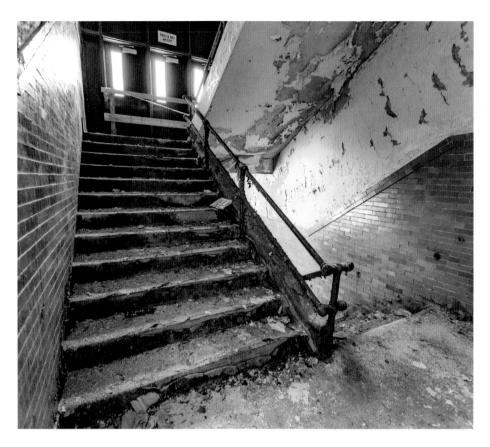

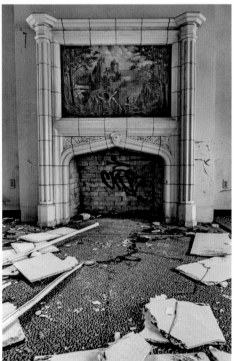

Above: This is not an exit.

Left: I can't say I've ever seen a fireplace in a school before.

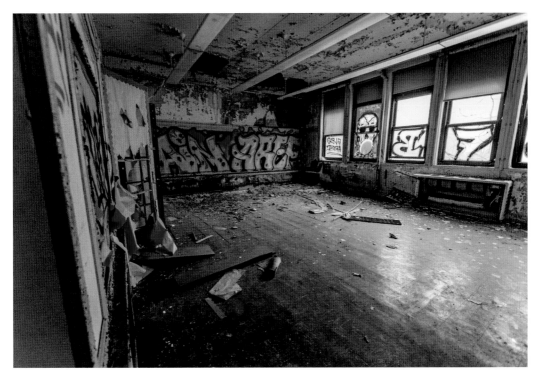

I expected more school desks and less graffiti. Silly me.

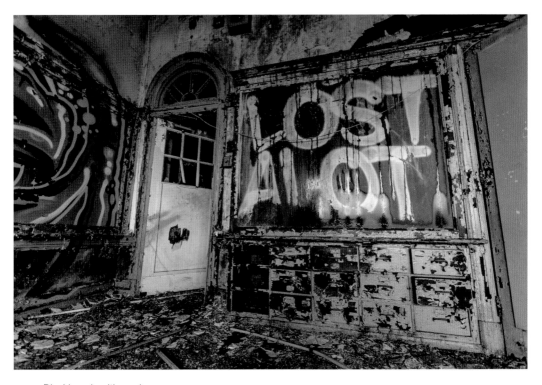

Blackboards with random messages.

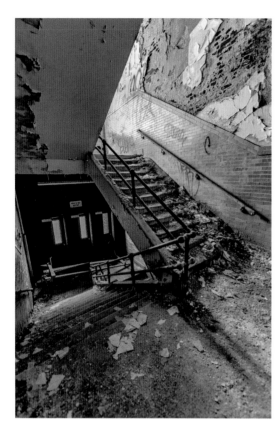

Left: If this is also not an exit, how did the kids get out of here in the first place?

Below: A sideways piano found in the auditorium.

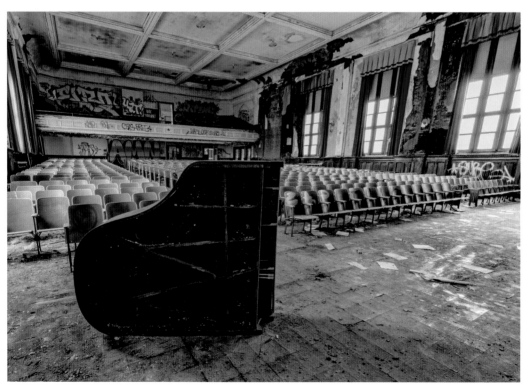

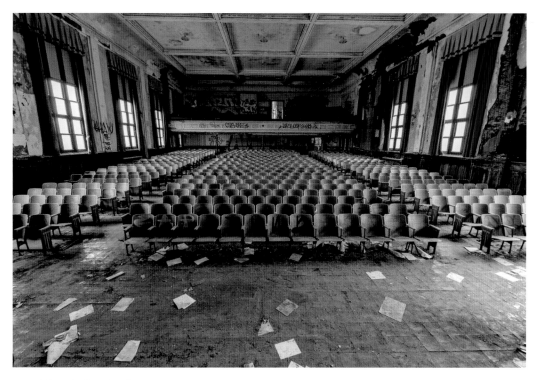

I love the fact that the curtains are still hanging there.

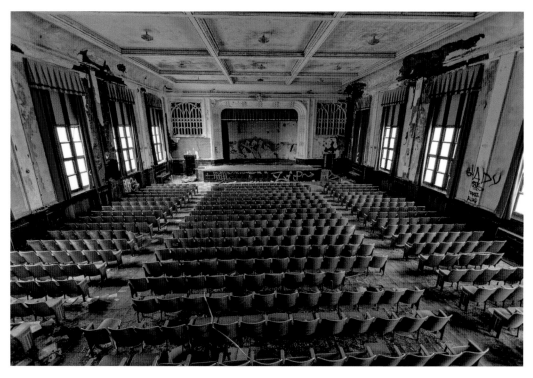

A bird's eye view of the auditorium.

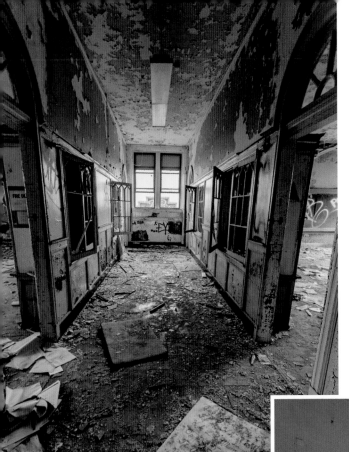

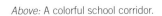

Above: A colorful school corridor.

Right: The graffiti colors match the map colors.
I wonder if that was done on purpose.

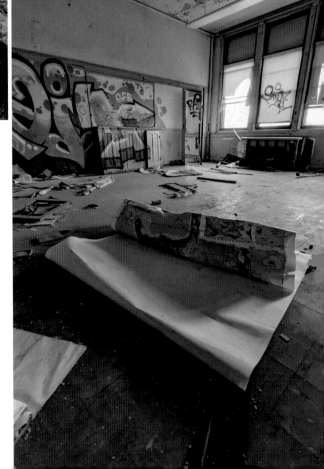

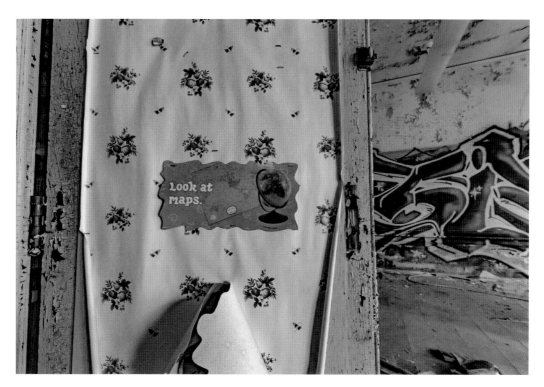

Looking at maps is my favorite.

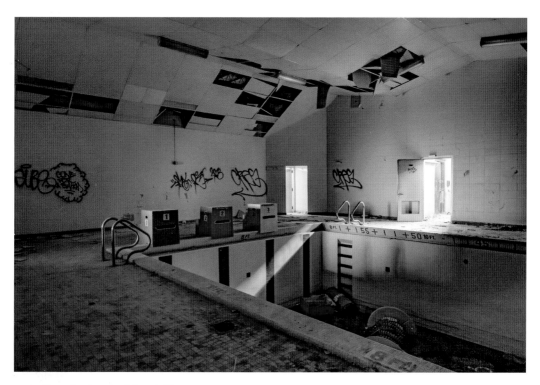

The school pool, a later addition.

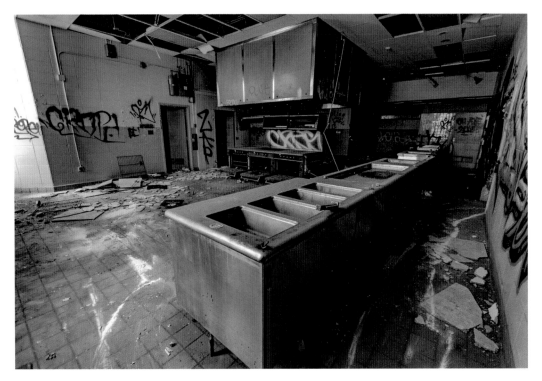

The school's main cafeteria.

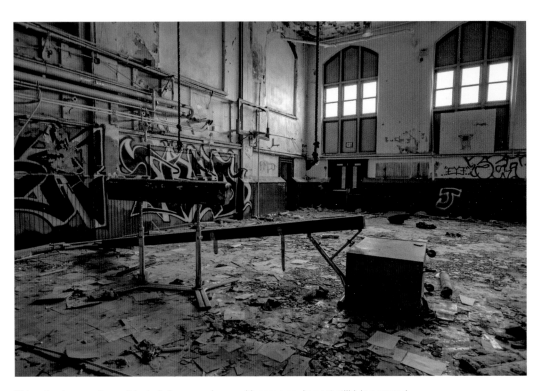

This school was so large, it included a second gym with some equipment still lying around.

2

MY LOCAL CHURCH

PRETTY IN PINK

When I heard about this abandoned church in my old hometown, I was quite excited as I currently only live a few minutes away. I was grateful to avoid a long drive this one time.

This beautiful Gothic church, with its gorgeous archways, opened in 1887 and was closed in 2014 due to dwindling attendance. Churches rely on parishioners for donations to keep things running, and with less money coming in, and less of a need for so many churches in Hudson County, this beautiful church met its unfortunate fate.

I cannot remember the last time I had such an easy time entering an abandoned building. We simply opened the door and entered from the basement. No climbing, no running. It was awesome. The smell of the mold is usually the first thing that hits you in an abandoned structure, and this site was no different. We go up the stairs to see the main floor of the church, and the sight is something else. With so many colors and the beautiful architecture, it is truly something to behold. Considering the church has been left dormant for five years, it is in good shape. We enter the loft area by way of some side stairs to see the church from above—what a view. I do wish that the pews were still in place, but I am glad for the opportunity to see this exquisite space.

I did return a couple months later, as I had heard an update about this beautiful building. It is being converted into apartments, with many of the church elements still intact throughout the proposed apartment plans. I am absolutely thrilled to hear that they will try to keep many of those elements throughout the space. I was able to peak through the front church window and did see new walls being put up. It was such a relief to hear this wonderful space will see life once again.

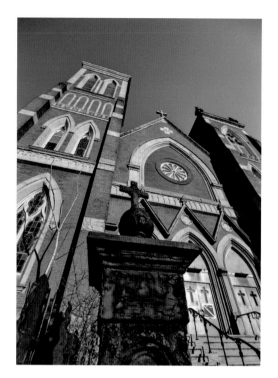

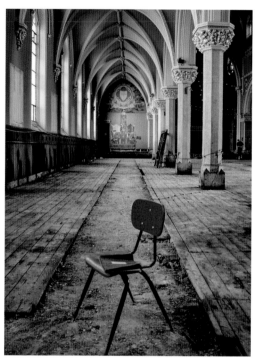

Above left: The front entrance of this old Gothic-style church.

Above right: One random school chair found inside the pew-less church.

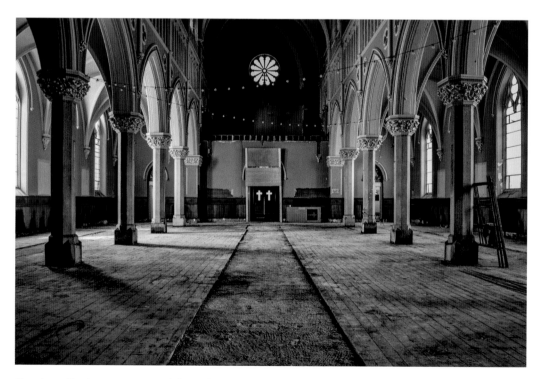

Churches without pews seem especially empty.

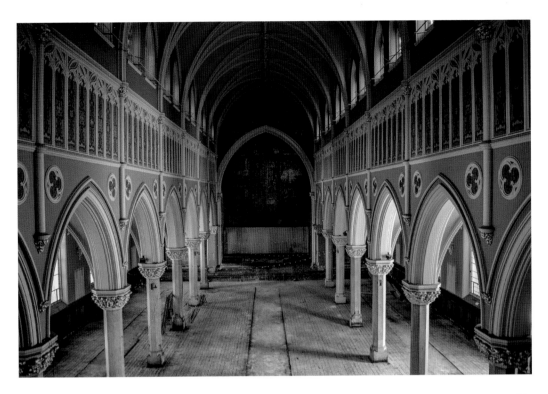

Above: I loved the colorful walls of this space.

Right: It appears a statue of Mary once lived here.

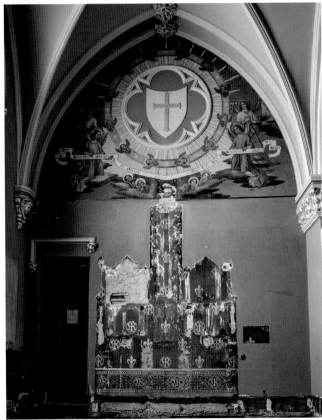

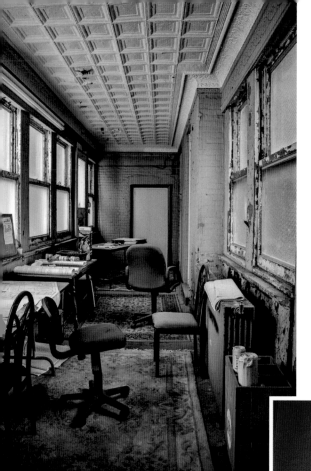

Above: Back offices of the church.

Right: Still a few beautiful examples of stained glass found here.

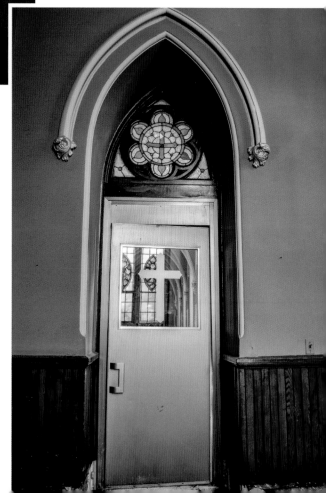

3

THE DINING CAR

WHERE YOU COME TO CHEW-CHEW

A dining car is pretty darn awesome when it comes to abandoned finds. I had seen so many photos of this before visiting; I could not wait to see it. I did not have much luck finding many sources on this mysterious restaurant, but it was quite the gem to visit.

This unique restaurant consists of a Pullman Dining car and a building attached with a catering hall and at least one apartment. I tried to enter the catering hall, but the rotted floor prohibited me from doing so. I do not attempt to walk across spongy floors, thanks to a previous experience. The bar was so destroyed, there was no sense in photographing it. The building itself was incredibly dark, and full of mold. The dining car proved to be much more interesting.

It seems that this restaurant closed back in the mid-2000s and has sat vacant since. What amazes me is how much was left behind. You can find tables, utensils, chairs, decor, and more. It is as if someone just closed business for the day, and then never returned. I know it was up for sale not very long after its closing, but it would appear that no one wanted to tackle this project.

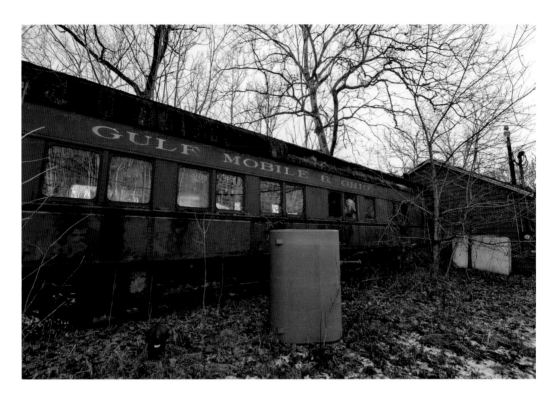

Above: A train car connects to a building; nothing to see here.

Left: Reservations are booking up quickly.

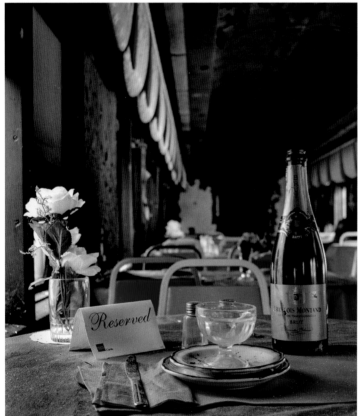

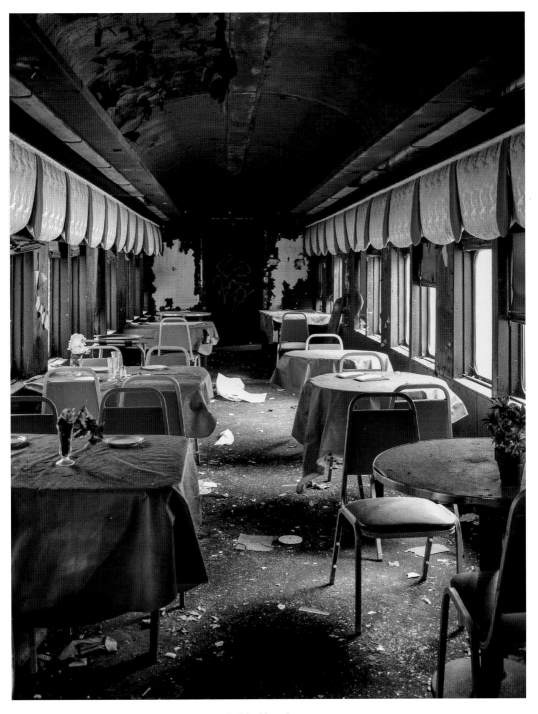

Sadly, the dining car does not appear nearly this tidy today.

4

BOWCRAFT AMUSEMENT PARK

NOW FEATURING 200 HOUSING UNITS

Normally, I try to protect the locations I visit by being vague in my descriptions as there is the constant battle with troublemakers. These troublemakers sprawl graffiti all over locations, use "bandos" as a party spot, or even commit arson. No explorer wants to see that happen to a location. Since this location is completely leveled now, I can speak freely.

Bowcraft Amusement Park in Scotch Plains, New Jersey, began in the 1940s as an archery range and grew from there. Eventually, a mini golf course was put in along with numerous rides for children and their families. This location was a bit personal for me; I came here often as a child. My family lived relatively nearby, and we spent many a summer at Bowcraft just enjoying the day.

It was surreal to visit the amusement park that summer morning in 2019 in the state it was sitting: no lines at the concession stand, no children laughing and running, no parents playing games to win their little ones that teddy bear—just simple silence. There were only a few attractions and stands left like bumper cars and the water shooting game. You could still see the tracks from the small train that ran around the property passing the concession stands and old basketball game, but now there was no one left to play on a property that was sold to create housing. The new housing project will include several buildings and a swimming pool. It's hard to say goodbye to a piece of your childhood. Funny enough, at the time of this writing, the Bowcraft website is still fully active.

Right: One of the main Bowcraft Amusement Park buildings, now demolished.

Below: Who doesn't love a funnel cake?

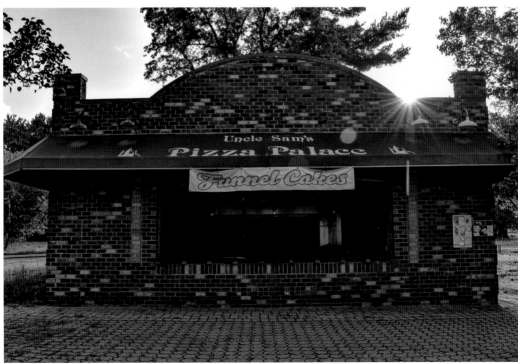

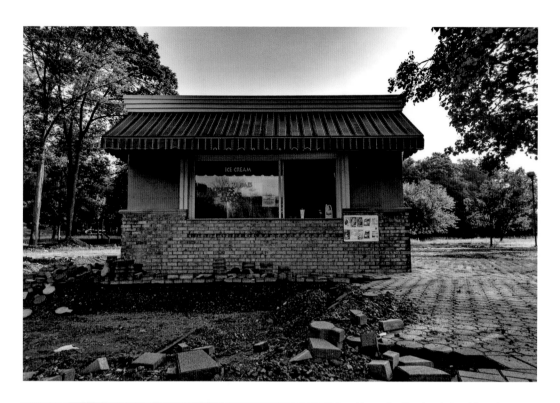

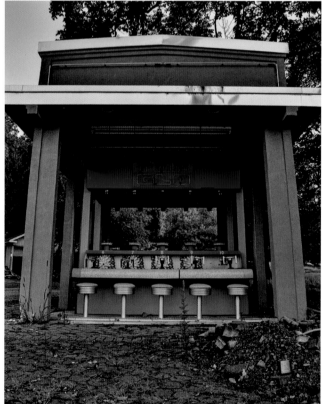

Above: Another treat stand found with broken pavers in front of it.

Left: One of the few games left here at the property.

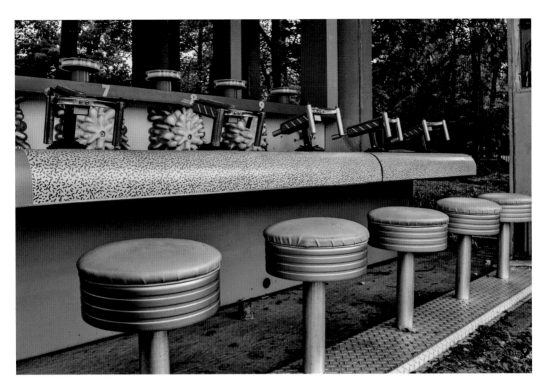

Game stools faded from sunlight over the years.

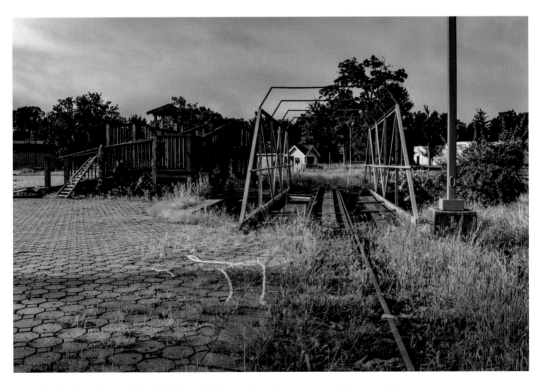

Tracks from the small train that used to transport park goers around the property.

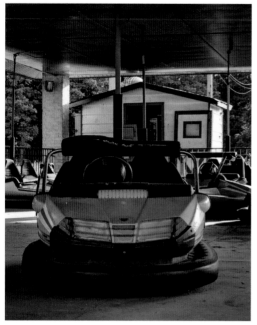

A few bumper cars left here.

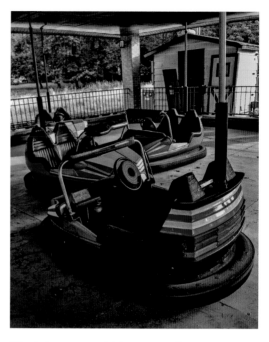

Why do I never see pink bumper cars?

Nature takes over the basketball game.

5

THE BROKEN JAIL

NO LAND OF OZ

Built by the same architect who built the famous Eastern State Penitentiary located in Pennsylvania, this former prison in Essex County, NJ, was built in the 1830s and placed on the National Register of Historic Places in 1991. Unlike Eastern State, our Essex County prison is not particularly open to visitors and does not offer daily tours. That doesn't really seem to stop visitors and it certainly does not stop the homeless from setting up shop here.

Not only are many of the walls crumbling, but the aforementioned homeless are a concern as well while visiting. Unfortunately, a heavily damaging fire in the early 2000s has left the prison in the state it is in today. While the prison closed in 1971, it served as home base for the Narcotics Bureau for some time before being completely vacated in 1989.

Upon entering the building, we are in awe of its sheer size. The place is massive. Immediately, you notice fallen beams from the ceiling with a huge gap when looking up. The juxtaposition of the incredibly small cells makes it hard to imagine spending years inside such a place.

Traversing the uneven ground in the prison is tricky and we try desperately not to disturb any of the inhabitants. While we're peering through bars, we hear others arrive and they are not trying to hide their presence. We quickly realize they are young explorers who are looking to do more than just explore. After alerting them about the inhabitants (and not to disturb them), we make our way to some back offices. We find a few pieces of discarded furniture, desks and chairs, and then we decide it is time we vacate the prison too.

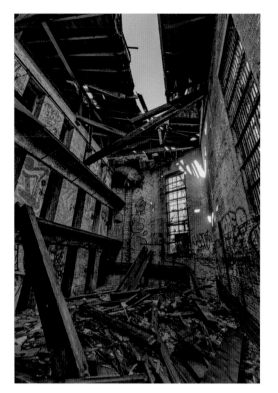

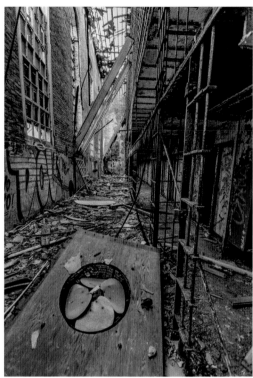

Fallen beams greet us as we enter the jail.

The neglect of the building shows.

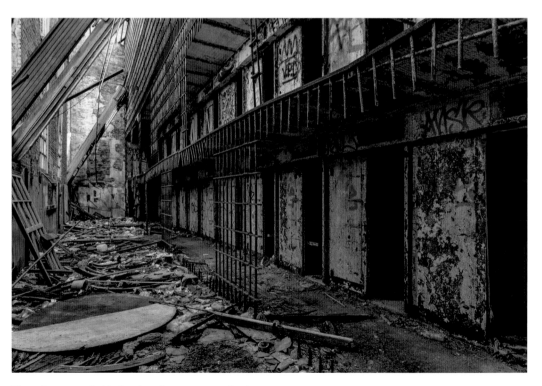

The cells were probably the size of your average closet.

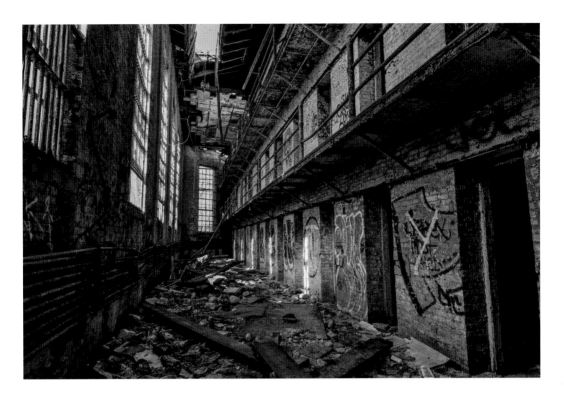

Above: Many homeless are purported to live here in the cells.

Right: Staircases leading to the upper levels of the jail.

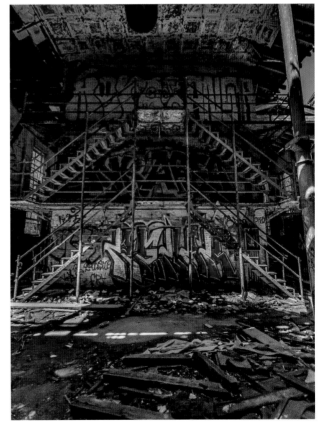

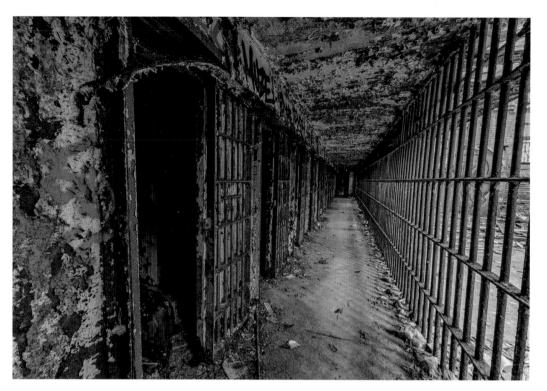

Rust takes over the space.

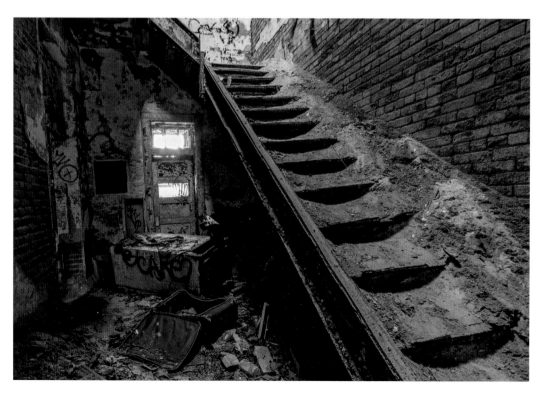

I pass through this corridor to make my way to back offices.

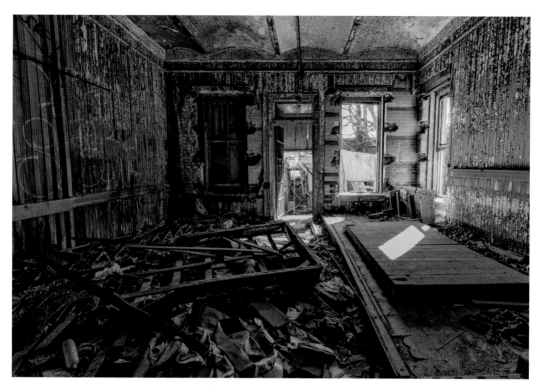

A rather large room, and I'm unsure of its purpose.

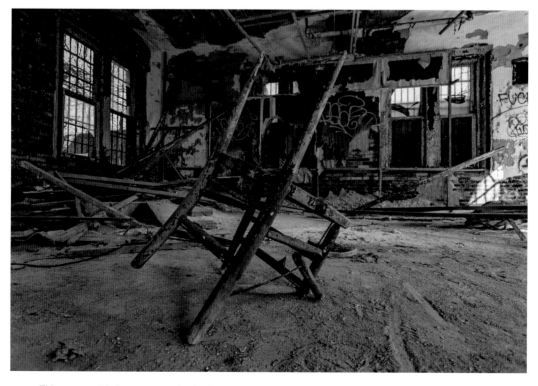

This was an old classroom; on the back wall, you can just make out a blackboard.

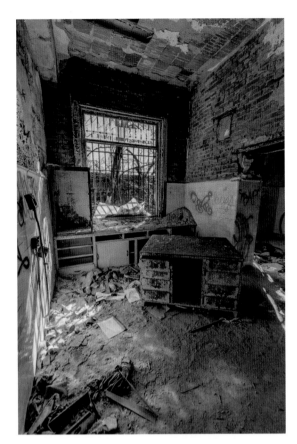

Left: Some back offices with desks and filing cabinets.

Below: In a separate building on the jail property, the furnace and other machinery can be found.

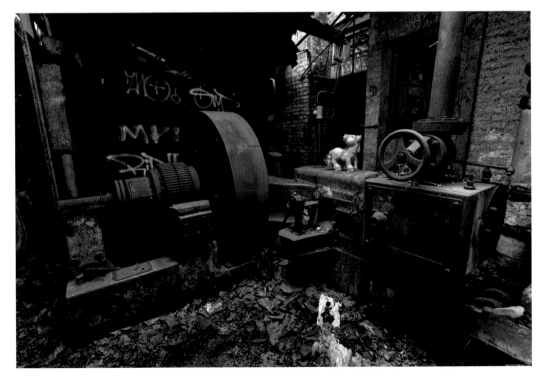

6

PLANE IN THE SWAMP

HOW BADLY DO YOU WANT TO SEE A PLANE?

To say this is probably the hardest explore I've ever done is probably putting it mildly. Yes, it is an outdoor location, so it would appear to be easier, but don't let that fool you. It took me a few weeks to find the actual coordinates for this downed plane in the woods. Once I had that information, I was so excited to finally go! I didn't realize what I was getting myself into.

A friend and I found ourselves unemployed briefly at the same time. Since we had time on our hands on this late summer day, we decided to go out for an adventure. We drive to this quiet town in north Jersey and park our car in a *cul-de-sac*. We quickly enter the woods knowing the coordinates I have are just an estimate; so essentially, we're trying to scan the dense woods to find a plane that crashed here back in 1960s.

This military jet, a Lockheed T2V-1 Seastar, is somewhat of a Jersey legend. This small jet left Brooklyn's Floyd Bennett Field when it encountered some mechanical issue and crashed in these woods. Fortunately, the two onboard made it out alive. It was reported that this plane landed in a dense wood swamp area with snakes. These woods are rather swampy, and this was a key piece of information I was missing; I thought it was just muddy.

Walking closer and closer to the jet, I started sinking more and more into the earth, having to repeatedly pull my sunken boots out of the mud. I was starting to become concerned. When I was just maybe twenty feet away from the plane, I hit what I can only describe as "quicksand mud." I sunk. The mud was up to my mid-thigh. Panicked, I desperately grab onto the soil so I do not sink further. The earth is literally swallowing me whole. HELP! Fortunately, I was smart enough not go alone (which was my original plan), and my friend acted quickly and found a large branch. She got that branch over to my hands and had to slowly pull me out of the mud, and it honestly seemed like the earth did not want to let go. The entire incident took perhaps five minutes, but it felt like an eternity to me.

After recovering from my anxiety attack, I attempt to pull myself together. I do not walk on the mud anymore and only step on the massive roots from all the old trees here. I do this until I can finally reach the plane, and now I am stepping on what looks like the skeleton of the back part of the plane. Wow, I'm finally here and I only had to almost die to see this.

To see a crashed plane up close is something I would imagine not too many get to do in their lifetimes. I am in awe of the moment. This plane has been sitting here for over fifty years (the Air Force removed its engine years ago). Viewing this plane from such a close vantage point, you can only imagine the panic its inhabitants felt when they knew the plane had an issue. To see the wings and the cockpit of this downed plane is truly something else.

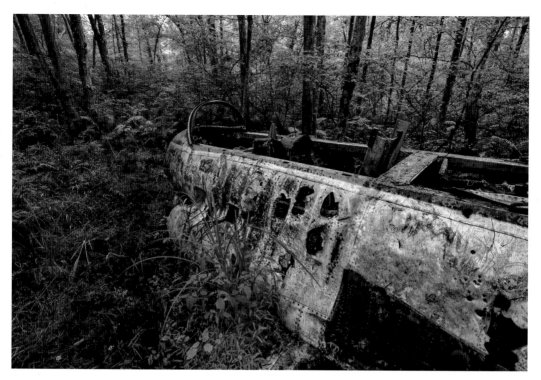

Side view of the Lockheed T2V-1 Seastar.

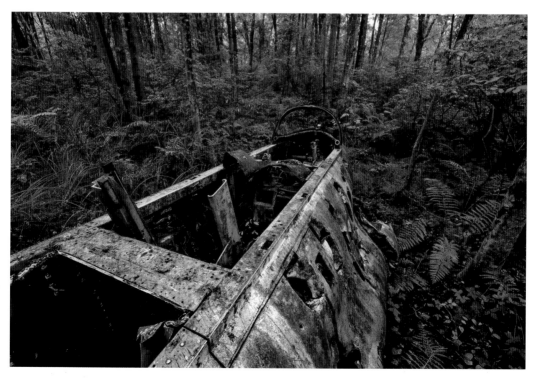

Today, the fuselage would almost appear it was in battle.

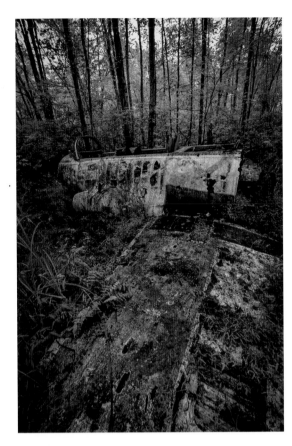

Left: Standing on the wing, so I don't sink in the swamp.

Below: Most of the cockpit has deteriorated after so many decades.

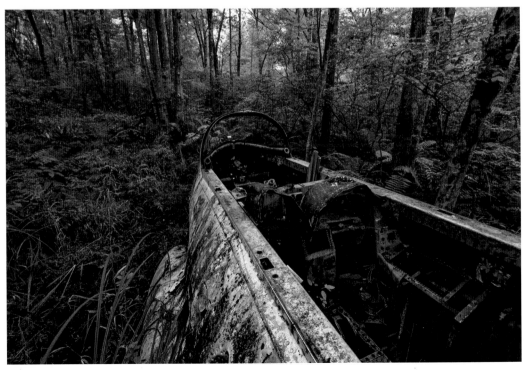

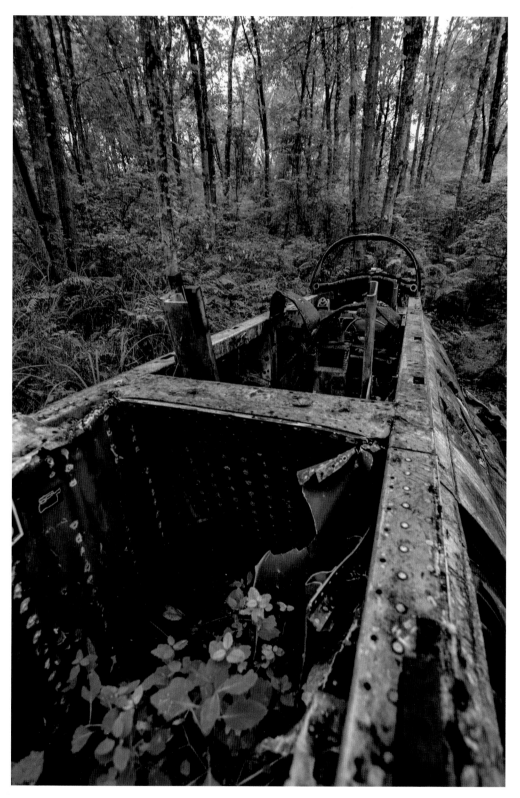

Nature slowly reclaiming her space.

7

THE ABANDONED TRAIN CAR

PERMANENTLY OUT OF SERVICE

Finding this abandoned passenger train car was easier than finding information on its history. This train has been sitting in this park for many years, but I feel it is shrouded in mystery due to the lack of information online about its story. I can say that the train car is along the Delaware and Raritan Canal that was built in the 1830s, and eventually the canal ceased operations in the 1930s. The state of New Jersey took over parts of the canal to save it from complete destruction and established the area as a park in the 1970s.

The rail line was operated by the Black River and Western Railroad, and its short line ran from Three Bridges, NJ, to Lambertville, NJ, as it became a passenger tourist railroad. The rail line was then cancelled in the late 1990s, and about half of this rail line sits abandoned today. I supposed this train car sits here as part of that abandoned project and is simply part of the bike path now for curious passersby.

OPPOSITE PAGE:

Above: The lonely train along the west Jersey canal.

Below left: As you see, many explorers have found this train along their route.

Below right: By the appearance of the sleeping bag in the background, I imagine someone has made this train car their shelter in the evenings.

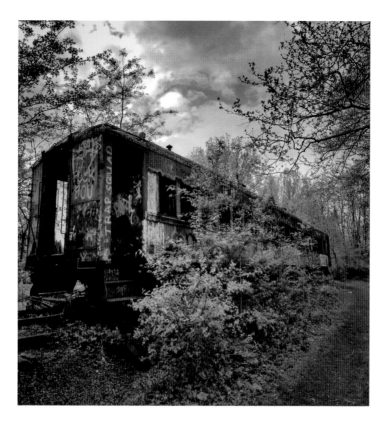

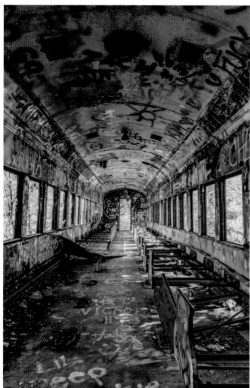

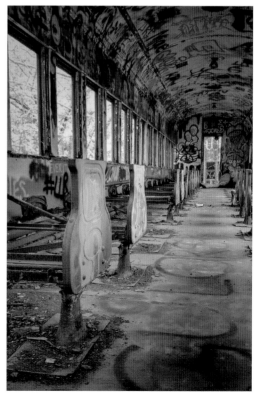

8

THE SANATORIUM

NOT HIPAA APPROVED

From what I can tell, this facility is often mistakenly labeled as a psychiatric hospital, but it was actually a tuberculosis sanatorium. The sanatorium started with caring for patients with tuberculosis that were considered highly curable. Later, the facility began treating all lung diseases. This healthcare facility was built around the turn of the century, and later abandoned in the late 1970s. Years later, a psychiatric hospital would be built next to the decaying sanatorium. Eventually, the psychiatric hospital was shut down in 2011. I only entered the sanatorium as it is rumored that there are security cameras and patrols on the psychiatric hospital side.

I had attempted to visit this facility once before and was deterred by the many State Police vehicles I saw driving by. Urbex is tricky sometimes, and timing is everything. Since I did not want to risk it, I returned another day to fortunately find it much quieter. So now that I can avoid security, I have to deal with a steep descent to enter the sanatorium. I had previously thought this wasn't the way in as it looked a bit too precarious to me, but unfortunately it was the way in. So down the hill I went. After a few stumbles, we arrive at the back of the building and only see a window to enter. Since I am not as graceful as I would like to be, my friend climbs through the window to find another way in. Fortunately, he finds a doorway that we can easily traverse.

We enter to find discarded furniture, discarded patient records, and even the morgue. I am starting to think abandoned hospitals are my favorite. We turn the corner to find what looks like a makeshift ladder to the second floor (which is actually a metal bar headboard.) I have certain limits in bandos—climbing a headboard to get to the second floor is one of them. I call another friend who visited recently and ask him about this passage. He advised that there is another way around that requires us to go back outside and around. I am beyond grateful for this information. We find our way around and find discarded furniture throughout the rooms and halls. It seems that this facility placed a lot of importance on fresh air based on the designs of all the screened-in balconies. This sanatorium is in a rather rural section of New Jersey and the perfect place for some fresh air and beautiful views.

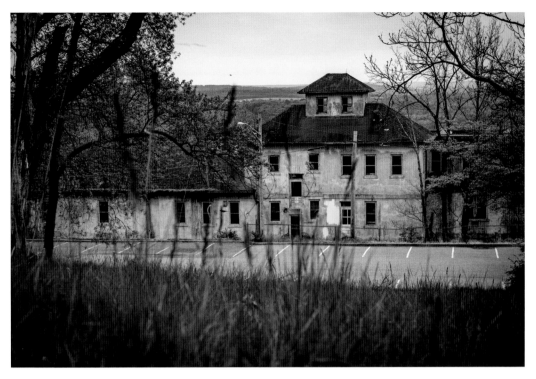

Outside the sanitorium.

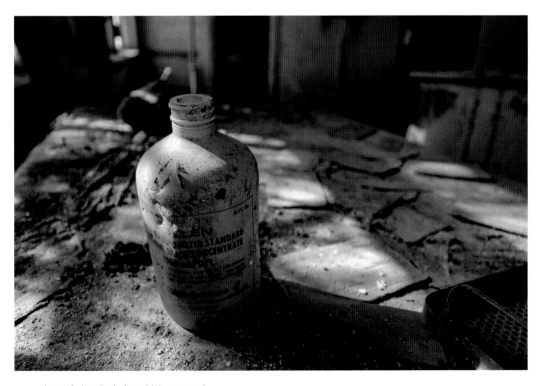

Lots of chemicals found lying around.

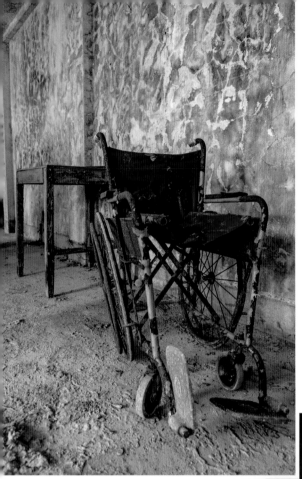

Above: It wouldn't be a true hospital visit if you didn't find a wheelchair.

Right: Many patient records were found strewn about.

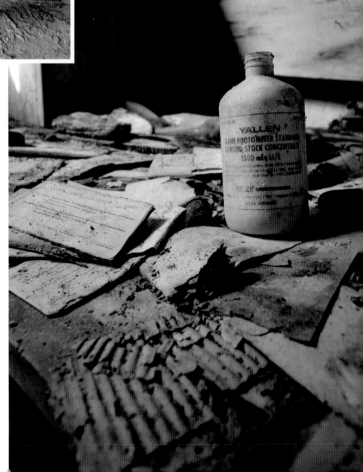

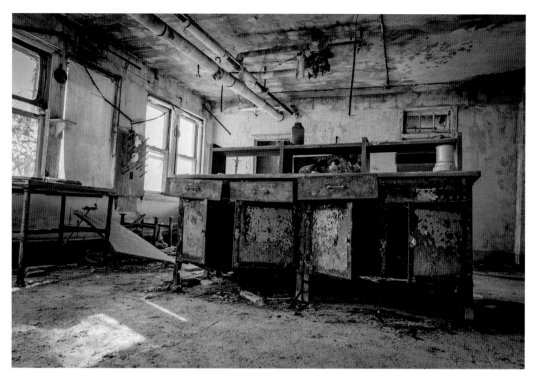

Random cabinets and desks found in this rather large room.

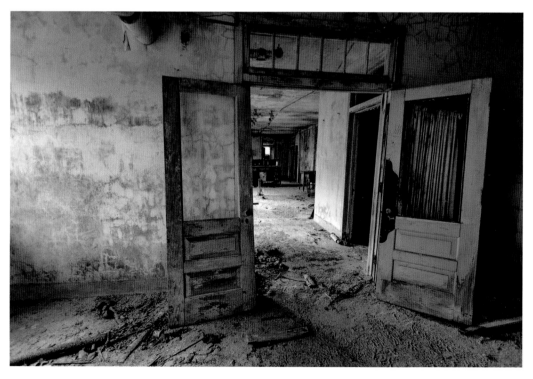

Unsure if that's mold or faded paint on the walls. I'm going with mold.

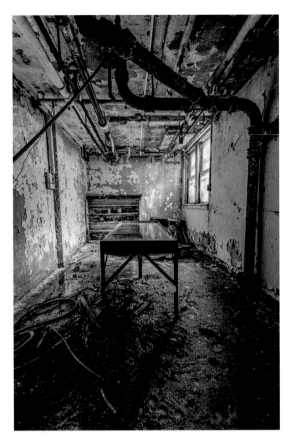

Left: The morgue.

Below: Sit outside on the deck and enjoy some fresh air.

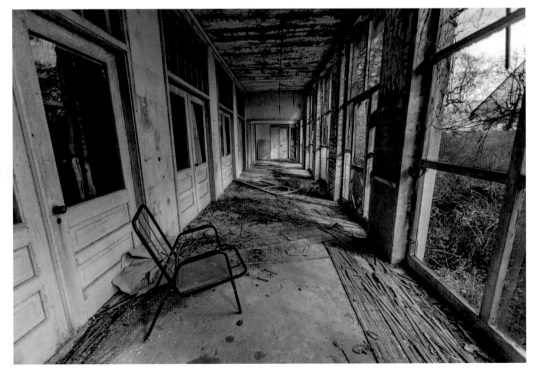

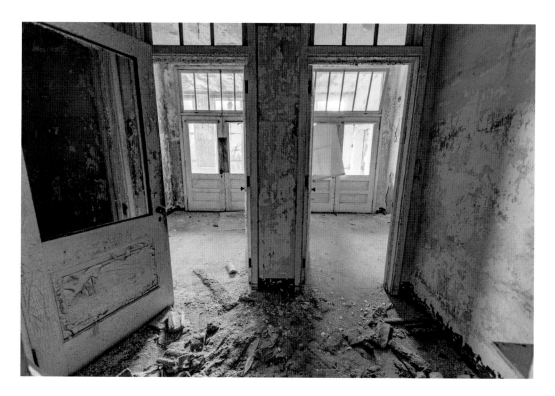

Above: Pastel colors cover the walls of these small rooms.

Right: Old furniture and yellow walls.

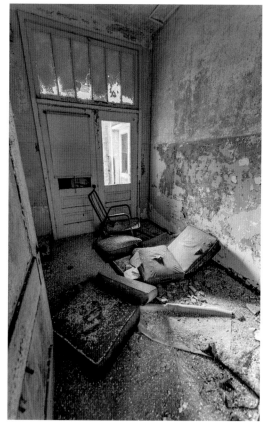

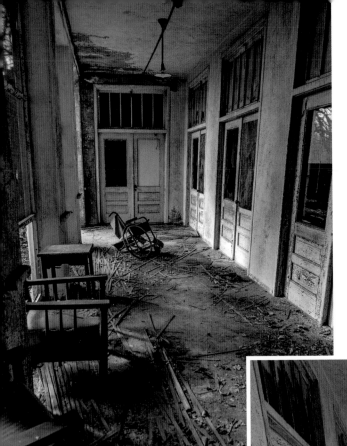

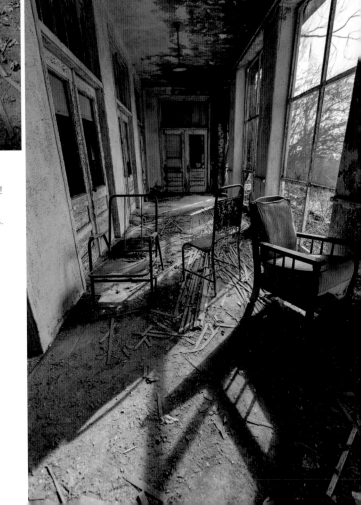

Above: One of the many outdoor decks found here, and look—another wheelchair!

Right: Sun peeks through the old windows.

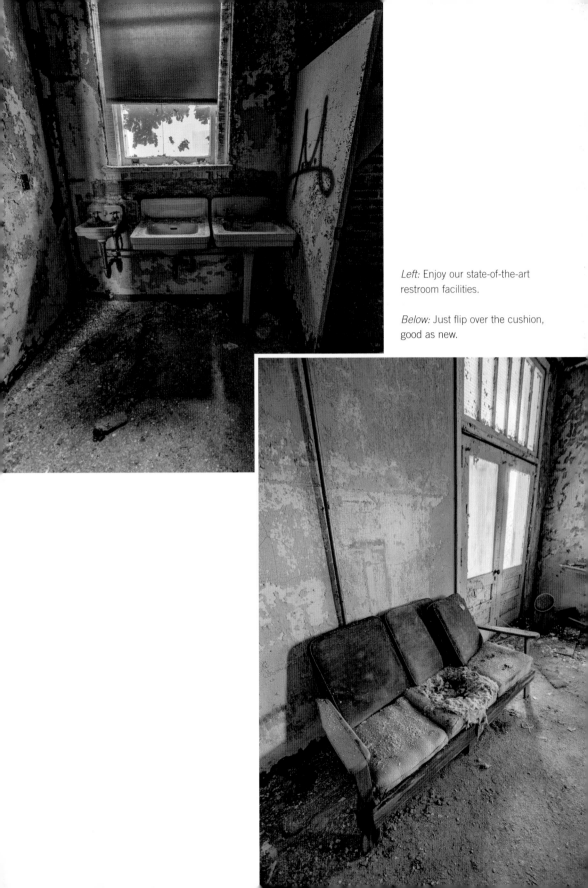

Left: Enjoy our state-of-the-art restroom facilities.

Below: Just flip over the cushion, good as new.

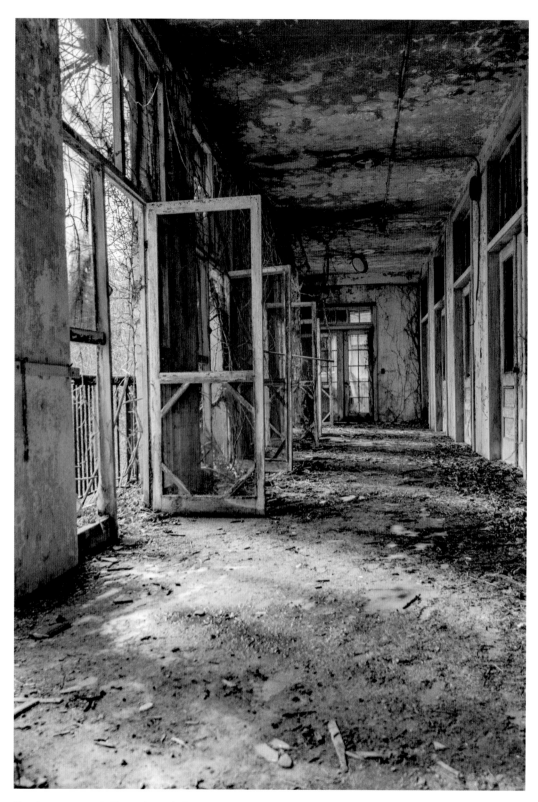

The doors are open to those who seek them.

9

JOYEUX

NOT SO HAPPY FOR THE GUY IN BROOKLYN

A boat named *Joyeux* (French for "happy") was abandoned in Sea Bright, NJ (a Jersey shore town), in the middle of the night. I felt like this was all over the local news in 2019. Apparently, the owner of this boat was heading home to Brooklyn from Maryland when he ran into a sandbar and could not get the boat sailing again.

As if the Jersey shore needed more reasons for folks to visit in the summer, this boat was photographed (what seemed to be) tens of thousands of times in the summer of 2019. To have a boat shipwrecked and abandoned on such a popular beach was too enticing for the locals.

In New Jersey, it is legal to abandon a boat without repercussions in emergency situations. Since the owner did not have any insurance on the boat, he simply walked away, and the township of Sea Bright was stuck with the removal of said boat. While many photographers in the area enjoyed the boat being there, it seems that Sea Bright did not. The boat was eventually removed.

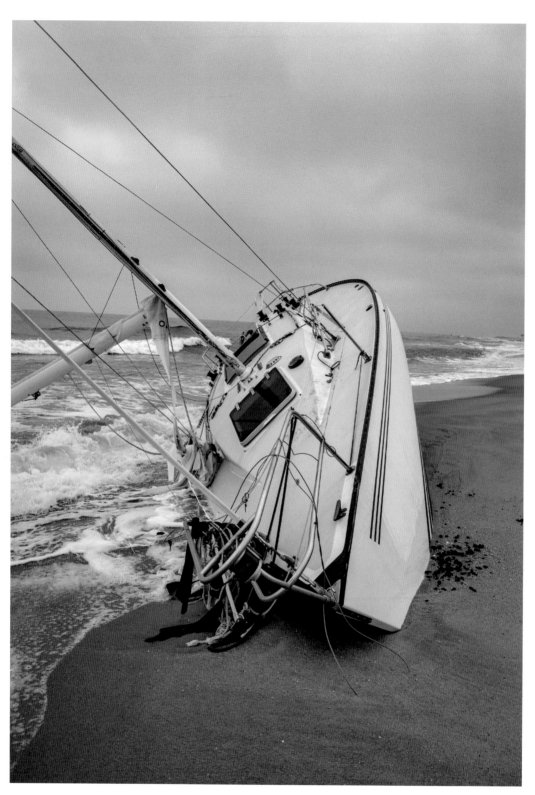

A three-hour tour, indeed.

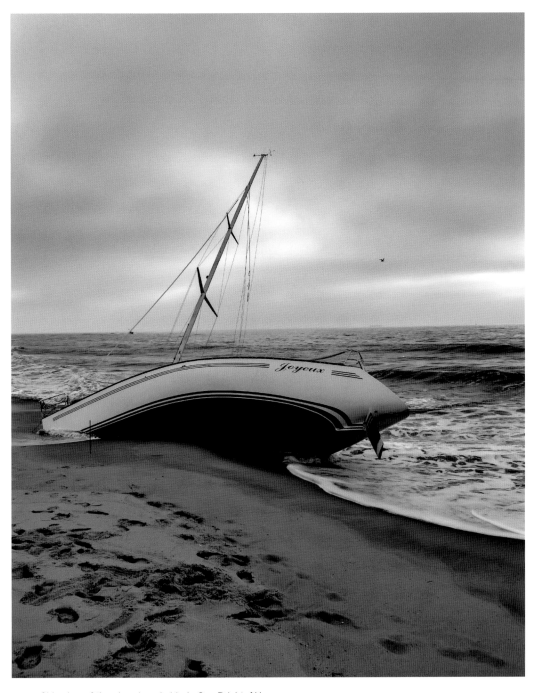

Side view of the abandoned ship in Sea Bright, NJ.

10

FARMER MANSION

THE 1850s BEAUTY

This Mercer County home was built by a prominent farmer for his family, which included eight children. The home was built in the Italianate style and some renovations were done later in the 1920s/1930s. While we found the home devoid of any belongings, the architecture was absolutely beautiful. Many fireplaces could be found throughout the home and bathrooms that were bigger than my current living room. This family lived well.

This stately home was later purchased by a pharmaceutical company in the 1980s. There are current efforts to get this abandoned home on the National Register for Historic Places to save it from the wrecking ball, which is apparently being considered by said pharmaceutical company. To see this stunning example of classic architecture meet such a fate would truly feel like a loss.

We enter the home from a back door. We were told this home had suffered heavy damage in a 2011 fire, yet we find no evidence of that. This was a home that was loved and built with great care. We enter these vast rooms that would rival today's mansions, with beautiful framework around windows, and even clawfoot tubs. The details in these historic homes cannot be found in new construction, and that's why so many explorers have such an appreciation for these structures.

We make our journey throughout the rooms, finding hallways that must have led to servant's quarters, as they were smaller and less intricate. We awe at the space. Surely this would be a massive project to get the home up to code, but I do hope to see this one saved one day.

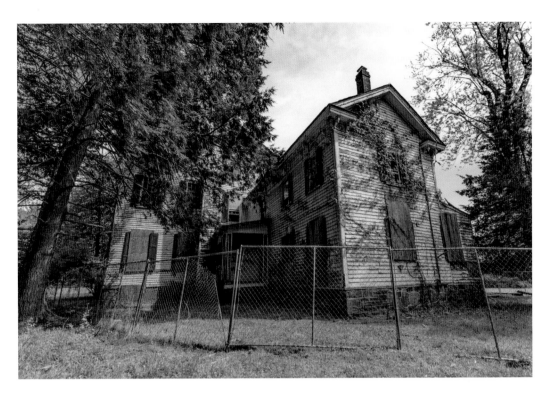

Above: Outside this beautiful mansion.

Right: I simply cannot resist a grand staircase.

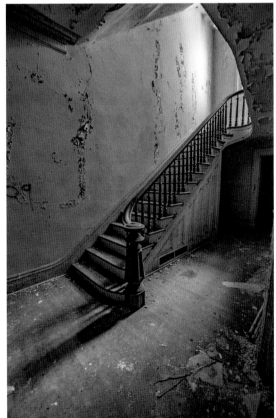

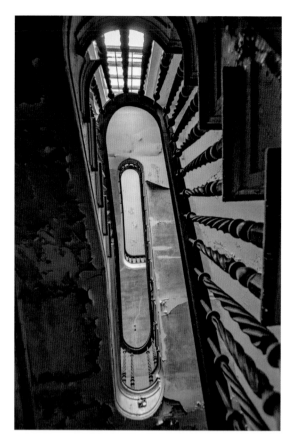

Left: Looking up the three-flight staircase.

Below: The windows were boarded up from the outside to protect them from being damaged.

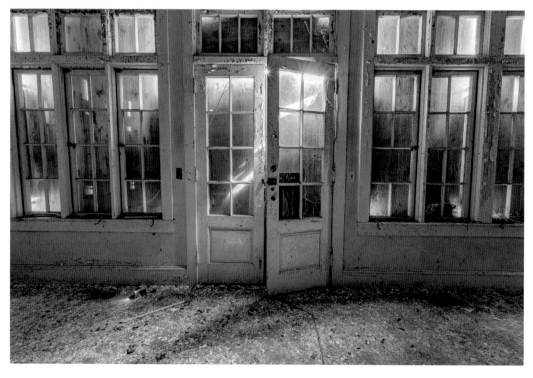

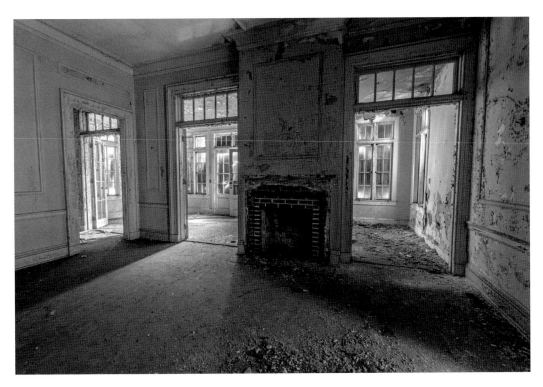

One of the many grand rooms found in this home.

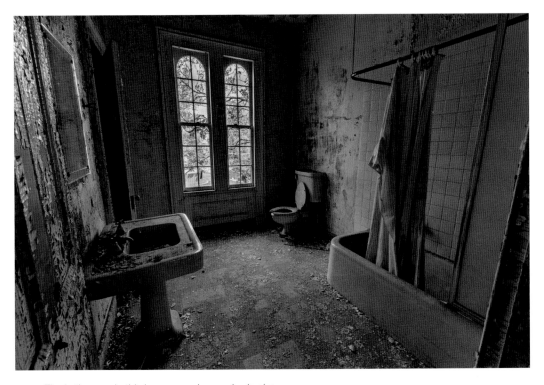

The bathrooms in this house were impressive in size.

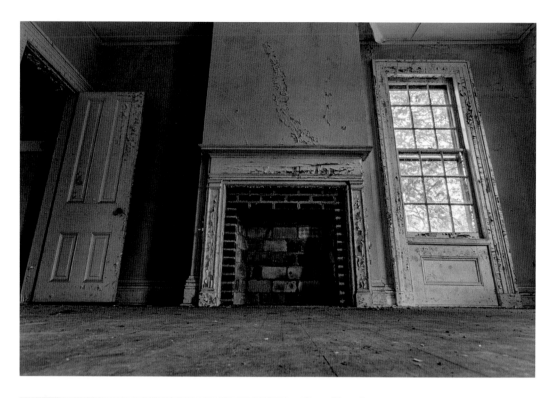

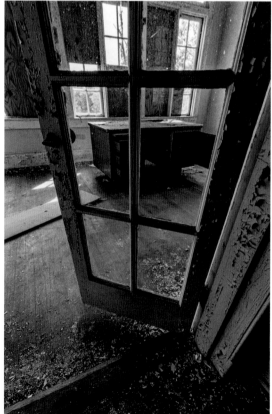

Above: Many fireplaces found in this once grand mansion.

Left: French doors always add a nice touch.

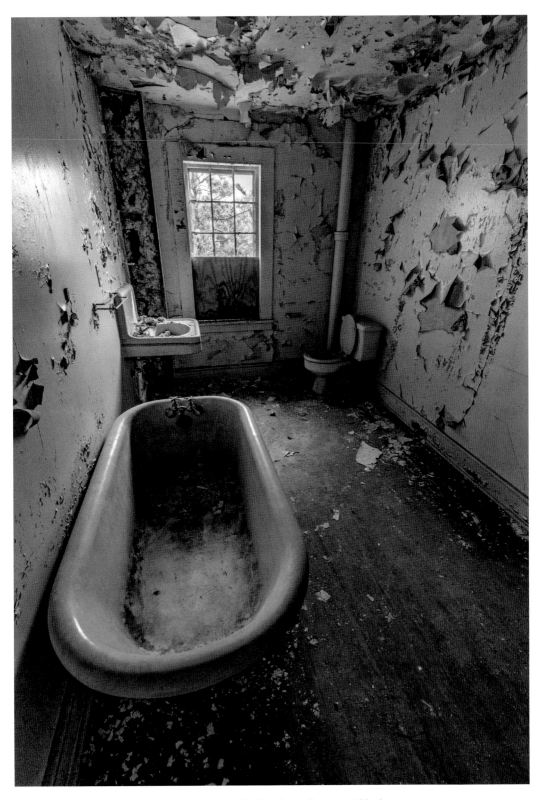

This smaller bathroom was still rather large. I believe it was the servants' bathroom.

11

THE HOUSE BUILT FOR CORNELIUS

CLUTTERED WITH BEAUTIFUL RELICS

When I entered this house, I had no idea how old it was. Truth be told, it didn't look any older than many other houses I had entered before, but after some research I was genuinely surprised. Apparently, this house was built by a father for his son, Cornelius. Cornelius inherited this home in 1853. This one-and-a-half-foot story home was not very large, but did have a somewhat strange layout by today's standards. The home was in the family for a while before being taken and sold by the tax collector in 1900. Another inhabitant took over the property in 1915, and according to tax records, this home still remains with that family today despite being obviously abandoned for some time now.

As we enter this home on a busy street in Bergen County, we find our way in rather effortlessly. We encounter the first two rooms: one appearing to be a kitchen, the next appearing to be some kind of workshop area. Afterwards, we make our way to the living room. The house is filled with many belongings left behind. Venturing into the next room, it appears that this home was being used as a business. Many files, ledgers, and keys can be found scattered throughout the space. Along with these many scattered items, we find an antique piano and sheet music. The objects in this home alone must be worth tens of thousands of dollars. It is hard to imagine anyone would leave all this behind.

We eventually make our way upstairs and this is where the true magic lives in this home. Although the house is quite cluttered, there are some real gems when it comes to furniture on this floor. We again find another piano and some art on the walls. This is one of those homes where you feel like the owners were very kind people, and perhaps some unfortunate luck befell them. So, while it is beautiful, there was certainly something very sad about the place.

This home was placed on the National Register of Historic Places in 1983 and remains vacant today.

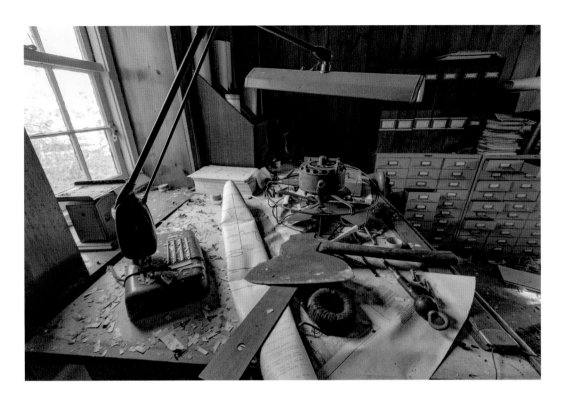

Above: The workshop is closed.

Right: An American life.

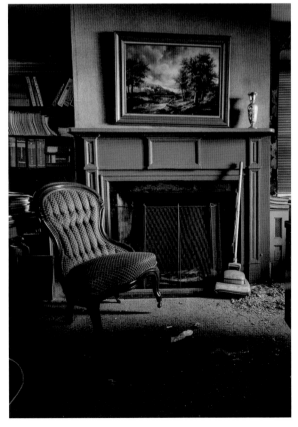

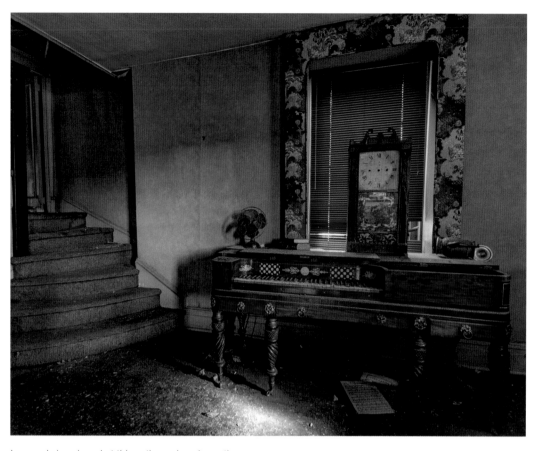

I can only imagine what this antique piano is worth.

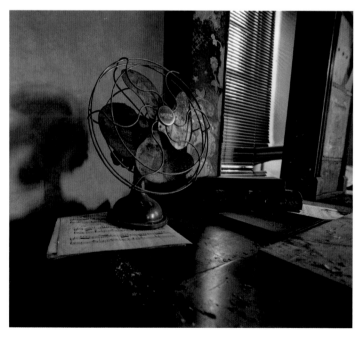

An antique fan holds down
sheet music.

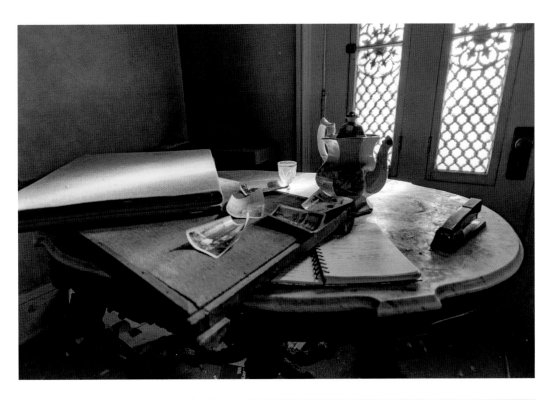

Above: You fancy a cup of tea?

Right: Let's go upstairs, shall we?

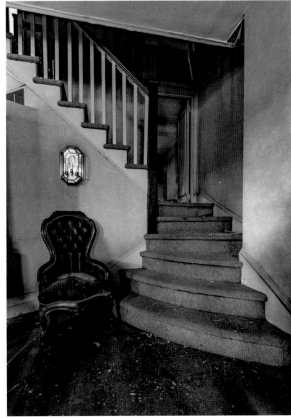

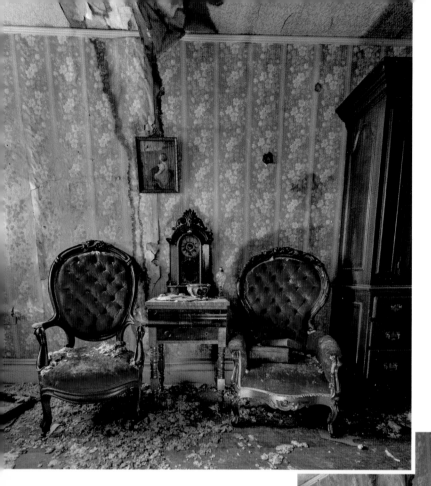

Above: Two of my favorite chairs ever.

Right: These people lived well.

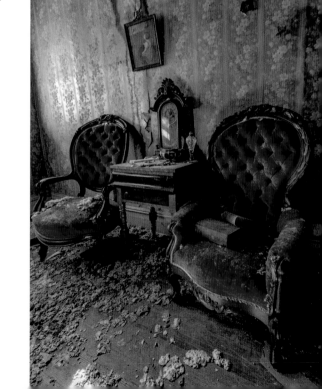

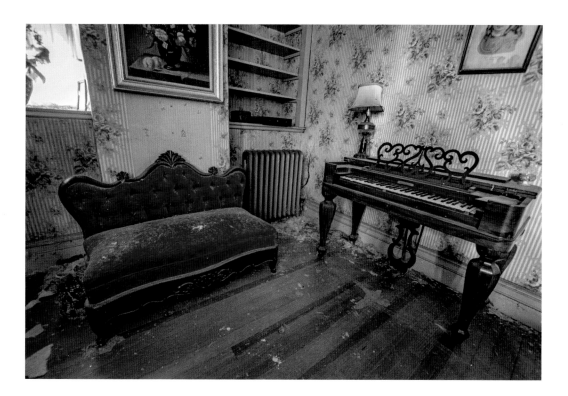

Above: While this room was small, it packed a lot.

Right: I wonder if the drawing in the photo is of a relative of long ago.

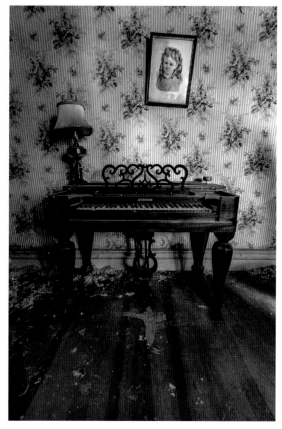

12

THE JUNKYARD

FORMERLY PICKED BY *AMERICAN PICKERS*

This south Jersey junkyard is somewhat of a New Jersey legend. While the junkyard has been closed for some time now, once a year the owner opens up the property to have a car show. I understand it is quite the spectacle. It was reported that in 2017 that the owner would no longer do the annual car show, as the traffic was too overwhelming for the rural town. However, I do know that the car show took place in 2019, because I tried to go. I had some car issues on the way, and a friend who was there called me to say there was no point in me trying to get there as traffic and parking were a no-go.

This junkyard contains amazing artifacts of south Jersey and nearby areas, along with many antique cars. It's a history buff's dream come true. Old gas station signs, New Jersey boardwalk signs, an old ambulance, and gas station pumps all can be found here. It's truly amazing. Now, I had heard that you may be able to enter the property with permission. When given the opportunity, I will always ask for permission first. I tried to call the owner several times as I was heading down one Saturday. I could not get anyone to answer the phone.

We arrived at the property and weren't even sure if we had arrived at the right place. Apparently, the junkyard goodies are hidden further back and were not immediately visible from the road. We park our car and I call out, "Hello?" several times as I near the house on the property. I am trying to be respectful of the owner, whom I believe still lives there. I get no response, but slowly walk deeper into the property and then I see all these magnificent discarded items just waiting to be documented. I try to make my way through the property as quickly as possible, seeing as much as I can. I do not know if the owner is here, if he will return soon, or if he will be angered by discovering my presence here without prior permission. I try to make the best of the limited time I have here.

I understand the History Channel's *American Pickers* visited this famous junkyard in 2013, but I did not get to see the episode. In any case, I do hope there is another car show in the junkyard's future as one could easily spend hours here photographing all the abandoned beauties.

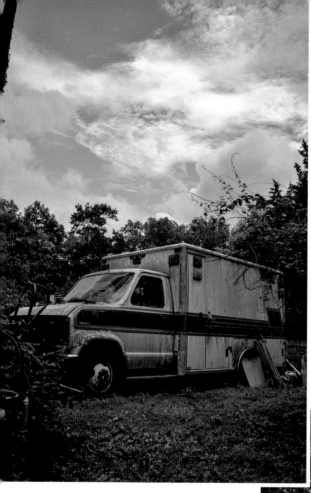

Above: Hard to believe an ambulance was no longer needed.

Right: The good old days when you could still have lead in your gasoline.

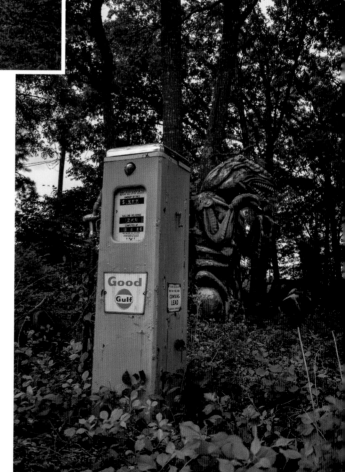

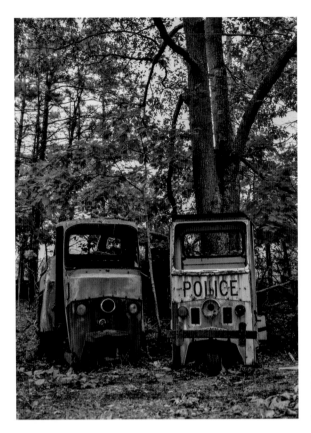

Left: I think I am too young to have seen police carts like this before, but they're adorable.

Below: Ah, the old black and whites.

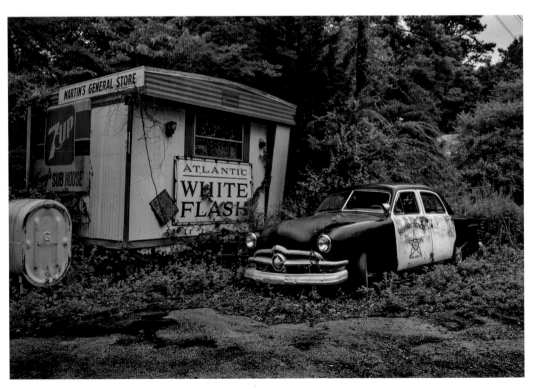

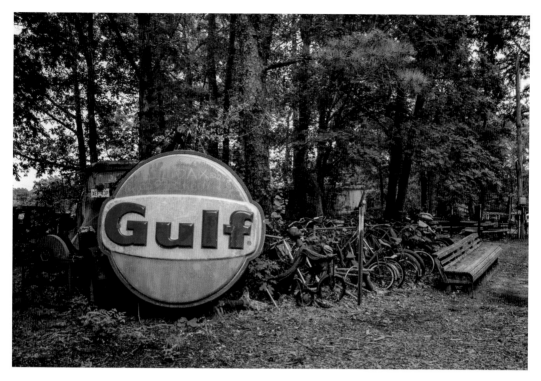

Many old signs found here at the junkyard.

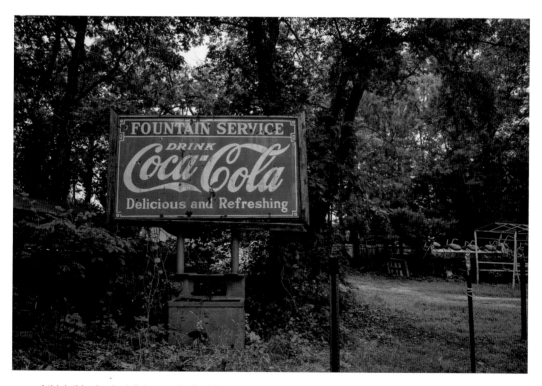

I think this sign is delicious and refreshing.

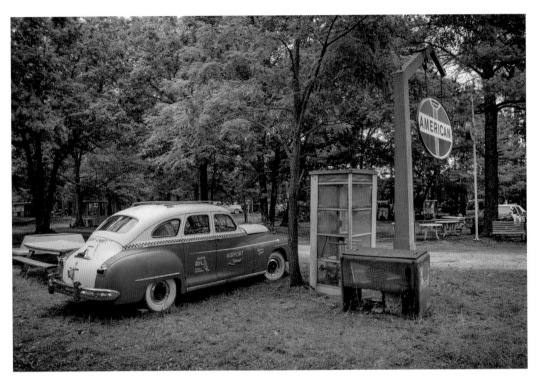

Why aren't cabs this colorful anymore?

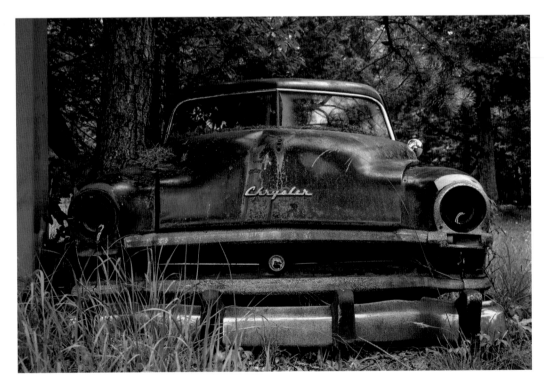

They don't make 'em like they used to.

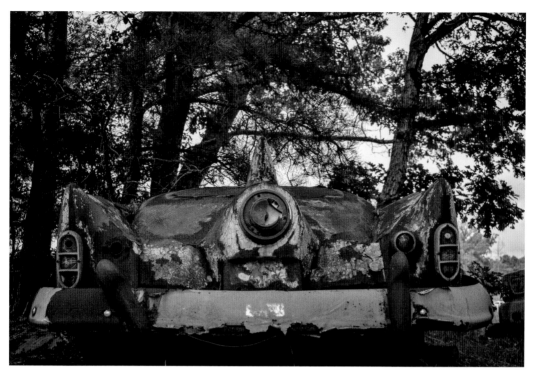

I do believe this is the rustiest car I've ever seen.

Above left: One of the old boardwalk signs made it here.

Above right: This junkyard is an antique car enthusiast's dream come true.

13

HOME FOR THE AGED

SENIOR BOARDING HOUSE

I wasn't looking for this property when I found it, but sometimes you just get lucky. This home for senior citizens was a huge, beautiful property. Sadly, I could not find much information on its history. This Mercer County senior home had very spacious rooms for its residents and a main hall where we found a fireplace and some antique furniture. It certainly looked like a place where they tried to make the occupants comfortable. I could not find when the place had closed or why, but I did find out that a charity was proposing a renovation to the twenty-four-unit property back in 2013. It appears that these plans did not come to fruition.

As we explore the place, we find so many items left behind: hair dryers, luggage, furniture, you name it. By the looks of the furniture and the peeling wallpaper, this place has been vacant for some time. Because of the neglect this property has seen, the smell of mold in this senior home is overwhelming. (It's always a good idea to wear a proper mask to avoid inhaling such contaminants like mold, lead, and the like.) For now, the property is owned by the city and awaits its fate.

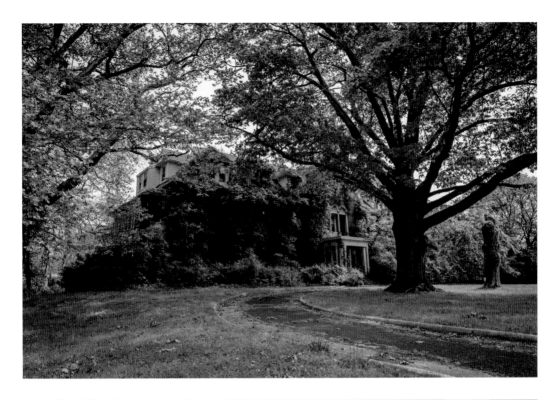

Above: There is so much growth here, you can barely see the building.

Right: So glad they don't make rotary phones anymore.

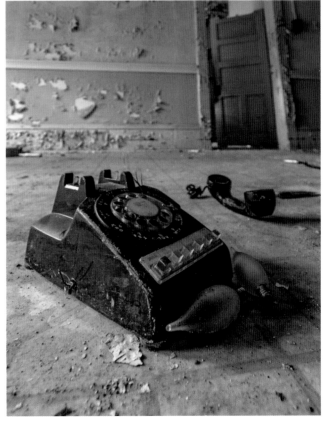

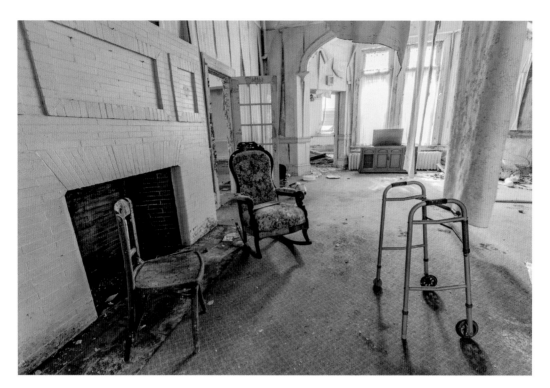

A nice place to relax by the fire.

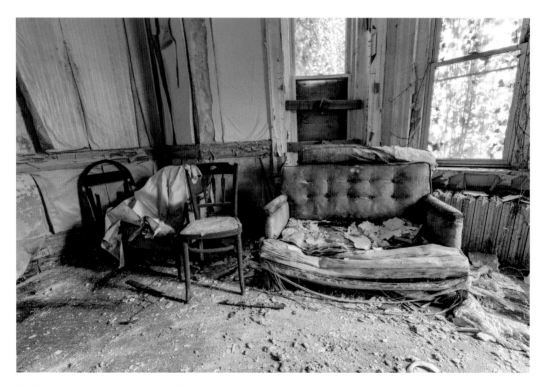

Furniture decays away in the main hall.

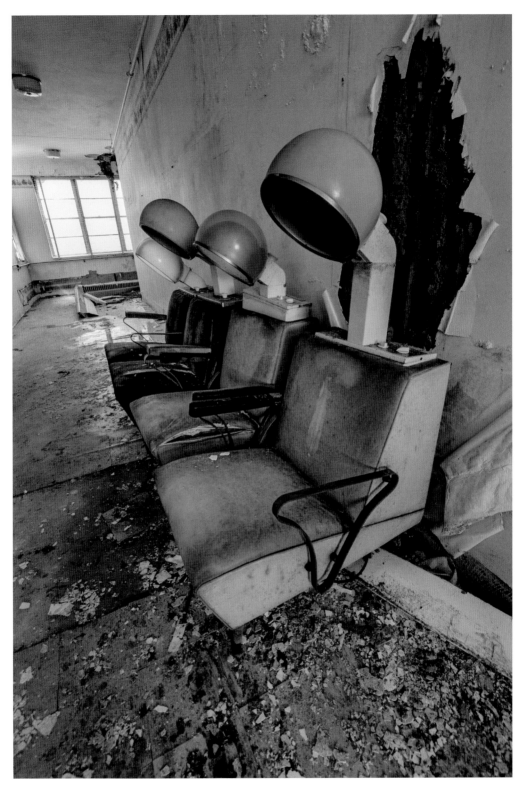

They just don't make 'em like they used to.

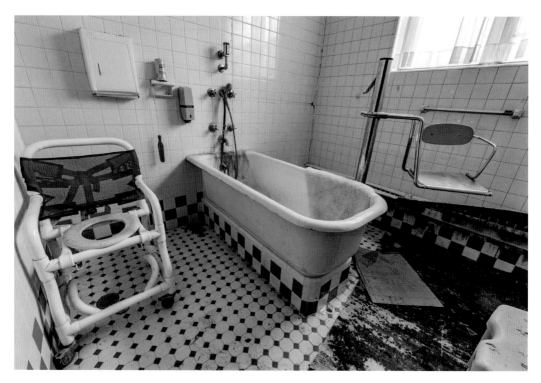

The bath therapy room.

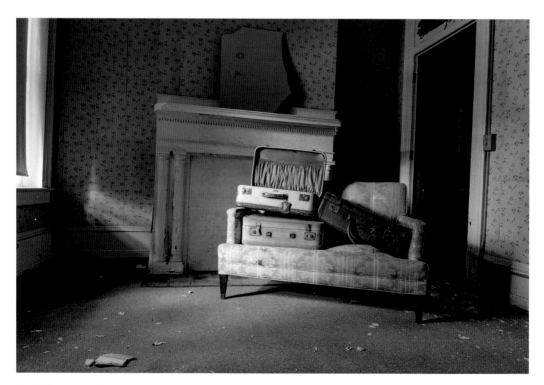

Looks like someone's ready to go.

14

TRAIN GRAVEYARD

IT'S THE LAST STOP

In New Jersey's Pine Barrens, a rare ecosystem, one can discover several discarded trains that would likely be forgotten by now if they were not so easily visible from the road. These trains that were banished here ran through this once very busy railroad junction before the demand for rail lines declined. Along with the uptick in families owning personal vehicles, this junction experienced a very unfortunate event. In 1922, a train going through this junction at 90 mph derailed, killing seven and injuring over eighty more. With road improvements, this unfortunate accident, and less demand for rail lines, the junction's heyday would not last forever.

The busy junction operated for many years, but was slowly cutting back on lines it ran over its time. Eventually, the junction closed for good in 1983. It was decided that leaving the trains at the defunct junction was less costly than removing them. While some were purchased, many were left behind. As mentioned, this place is quite visible from the road, so many have visited the trains over the years despite the area being off limits. Signage was put in place to commemorate this busy railroad junction and the tragedy of 1922.

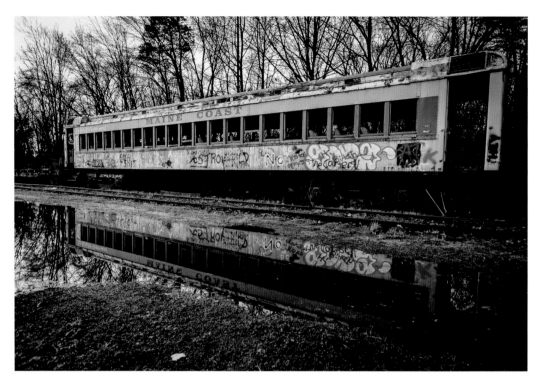

Reflections of trains past.

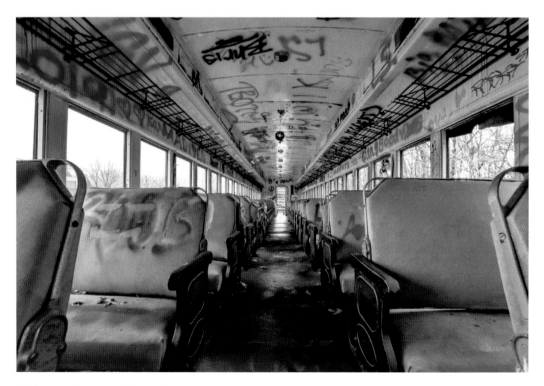

Sit down and have your ticket ready.

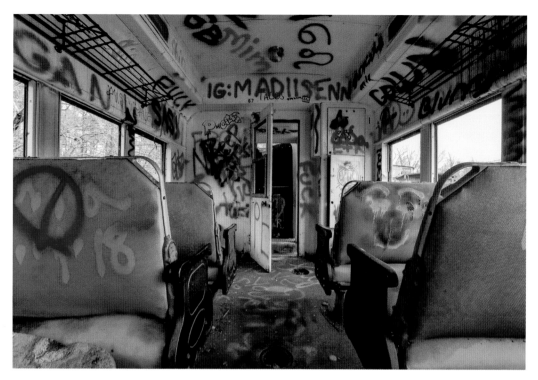

No passing in between cars please.

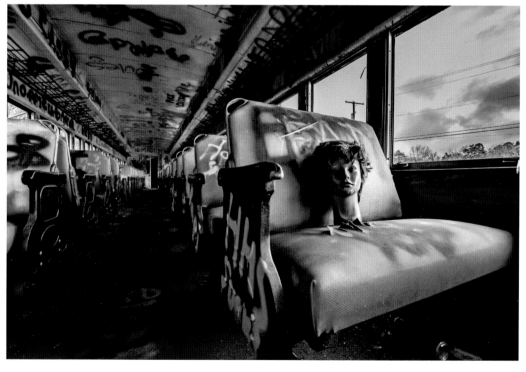

That was not my head, but I was glad someone left it there.

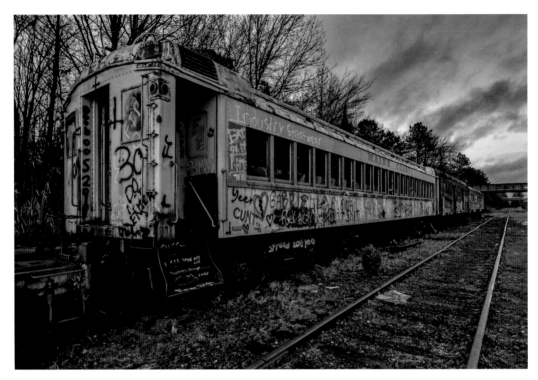

The other trains there were much more difficult to enter, so I didn't attempt.

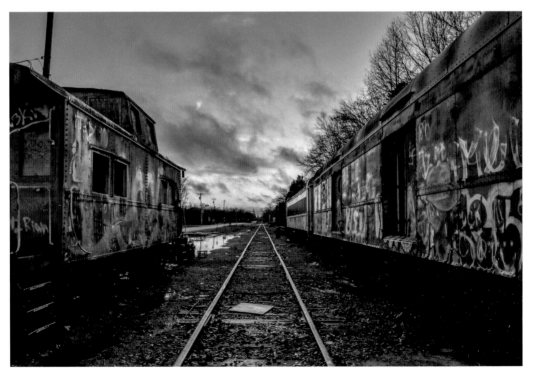

As the sun sets over the train graveyard.

15

THE COMMUNITY CHURCH

SERVICES HAVE BEEN DISCONTINUED

This church, found near the Delaware River, is massive, standing at over 20,000 square feet. Not only is it grand, but it is beautiful. What I believe to be built in the Gothic Revival style, this church closed its doors for good in 2007. The church was originally built in 1875 and operated as a Presbyterian church until 1993. A year later, a new church and community center took over the space and operated the church until 2006, eventually closing the community center in 2007. It has sat vacant since.

Currently, the city owns the property, but that doesn't appear to stop the visitors from coming to church. Considering it has been closed for over a decade, the church seems to be in pretty good shape with minimal graffiti. While the one room we entered was completely collapsed, the bulk of the church seems sturdy and still contains many belongings from years past. The beautiful stained-glass windows are certainly the highlight in this place of worship. The craftmanship is undeniable and I'm glad to see that so many of those windows were still intact.

I recall the basement containing many toys and furniture, all left behind by the previous owners. We eventually make our way to other parts of the property that included a computer room, and a rather large hall containing a small stage. I can only assume this part of the property was the community center. The city was asking for proposals from other congregations, or developers that may want to repurpose the space for housing. In any case, I do hope this church will see life again.

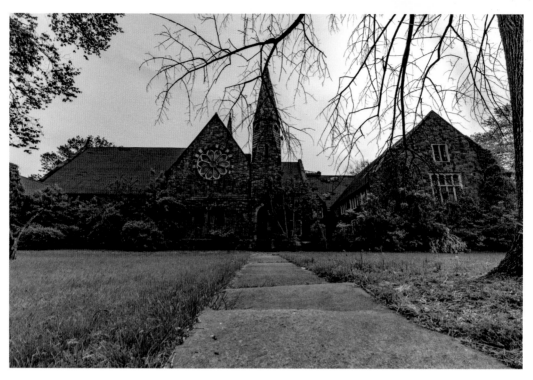

Even with the photo, it's hard to comprehend the size of this property.

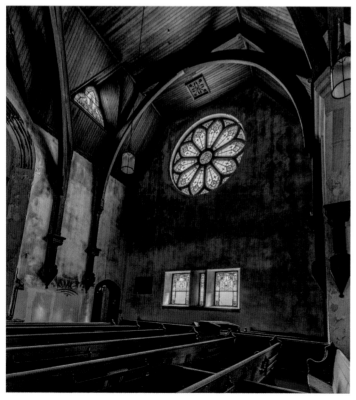

These stained-glass windows are breathtaking.

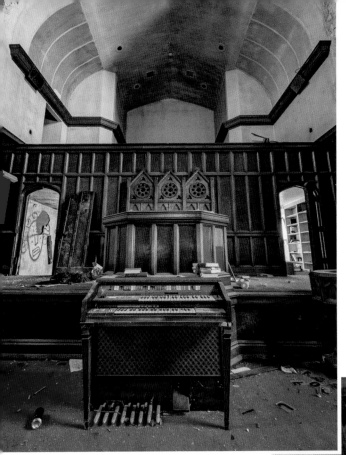

Above: The church organ.

Right: Pews filled with discarded items.

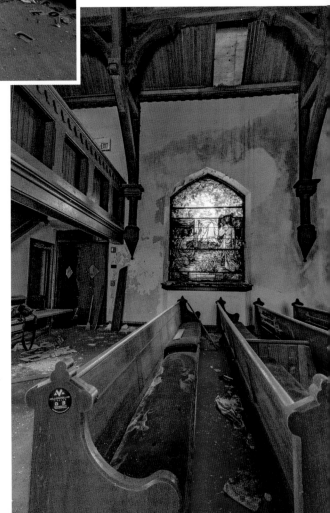

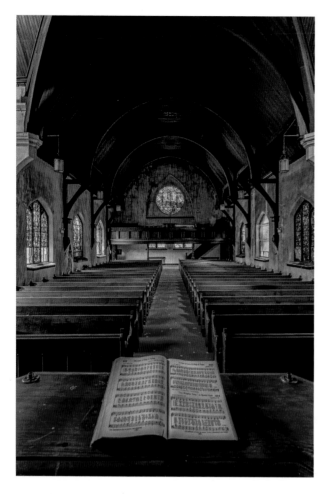

Let us pray.

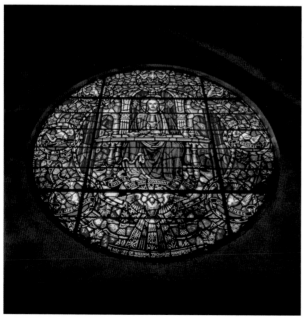

The back window and all its
glorious detail.

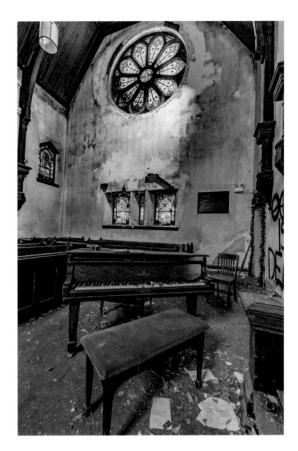

Right: Some light creeps into the decaying church.

Below: From the balcony.

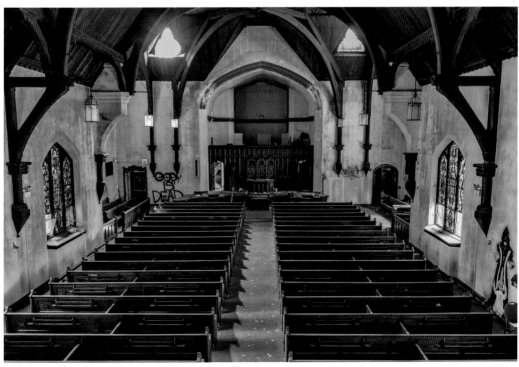

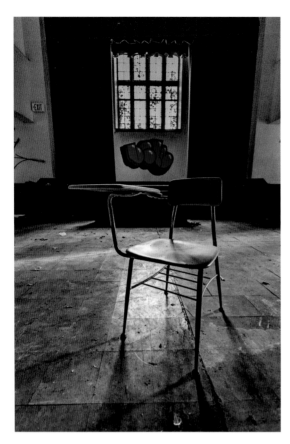

Left: A lonely chair before the stage.

Below: A back room in the community center of the church.

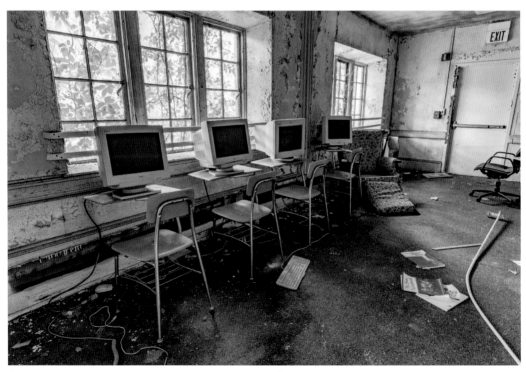

16

ROADSIDE FINDS

I PULLED OVER FOR THIS

Some things are just found on the side of the road or out in a field somewhere. Since I often drive around New Jersey aimlessly, I frequently find abandoned property that may have a good story behind it or maybe no information can be found on it at all. In either case, if it catches my eye, I simply must pull over and photograph it. In this chapter, I will show you some hidden Jersey gems—some more well-known than others. The history—or the mystery—draws me in. I hope it does the same for you.

This one was a fun one to research. What I had originally thought to be a random plane in a field behind a house turned out to be a former airport in north Jersey. The airport closed in 2013, and once consisted of ninety acres. There were proposals of starting a car business on this property, but the community fought back. I'm unsure where the property stands now, but I know it was purchased to house equipment for a power provider. If I have identified this airplane properly, it is a Piper PA-23. I will be checking back on this property and this airplane to see how this story unfolds.

Cape May has a famous concrete ship (yes, you read that right) decaying away off Sunset Beach, named the SS *Atlantus*. The ship was constructed after World War I and put out of commission after only two years of service. A few years later, the ship was purchased to help complete a ferry dock and brought to Cape May. While the ship was moored there, a storm came along and the *Atlantus* broke free and ran aground. Several attempts were made to rescue the ship to no avail. Over the years, the abandoned ship has deteriorated in the Atlantic Ocean with many locals coming by to visit the forgotten decayed beauty.

Futuro houses were designed by Finnish architect Matti Suuronen and made of fiberglass-reinforced polyester plastic and resemble UFOs. Approximately 100 of these houses were made in the 1960s and 70s, and only about sixty in the world survive today. We are fortunate enough to have two of them in New Jersey. This particular Futuro house is decaying in south Jersey as part of a marina. The public can still visit it, but in its current state, it in no way reflects Suuronen's vision. The public had difficulty embracing such an unusual concept, banks hesitated to give loans on them, and some were purposely destroyed. I'm glad this one survived.

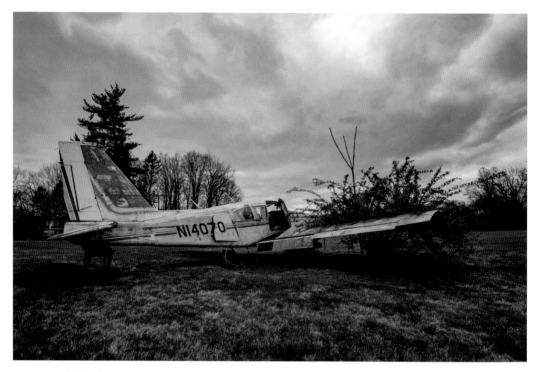

The Piper PA-23 will likely never fly again.

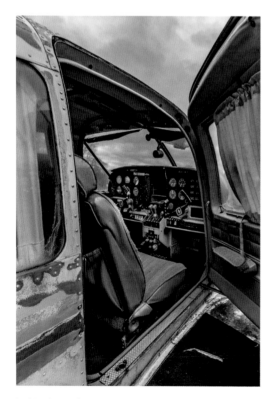

Inside the cockpit.

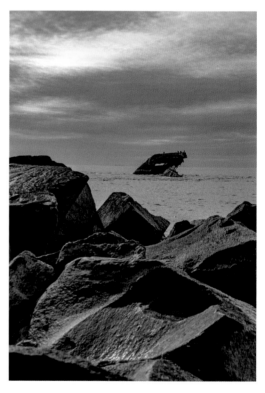

The SS *Atlantus* off Cape May.

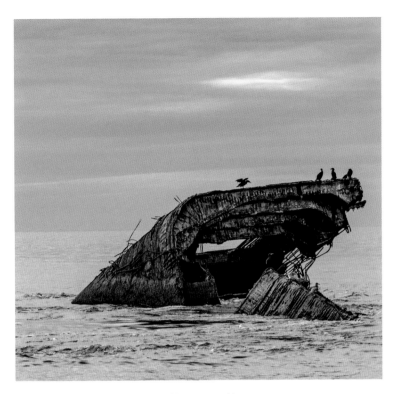

The birds seem to have a love for old concrete ships.

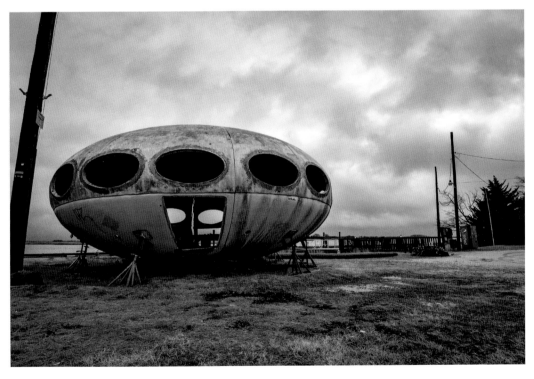

The UFO house has landed.

These next two photos were simply fun roadside finds. When someone thinks of New Jersey, I'm sure they do not picture rural scenes, though we have many farms throughout the state. Along these more rural areas, many abandoned homes, vehicles, and more can be found. When I stumbled upon this car and silo, I was struck by the decay and rust. My friends and I immediately pulled over to photograph it. There was a home found behind this rotted silo; since we were not sure if there were occupants, we left quickly. With this beautifully aging home, I was heading home when I stumbled upon this decaying site. No trespassing signs were visible, and the deterioration was obvious. I was sad to see this old farm abandoned here, but glad I had a chance to photograph it.

Along with abandoned roadside homes and the like, every now and then you hear about an airplane. This rather large jet from the U.S. Air Force rots away in a south Jersey junkyard. I kept seeing photos of this jet and had to see it for myself. A friend was kind enough to assist with the location, and when I arrived, I did not realize that I would have to shoot this plane over a six-foot fence! No one said photography was easy. It's almost beyond comprehension how large this aircraft is. I was in awe, took some photos, and said goodbye to my mystery military plane.

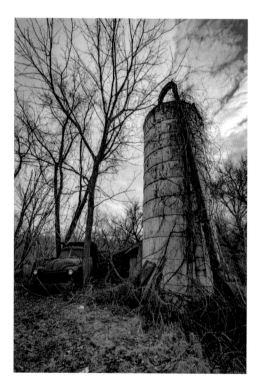

The old truck and silo.

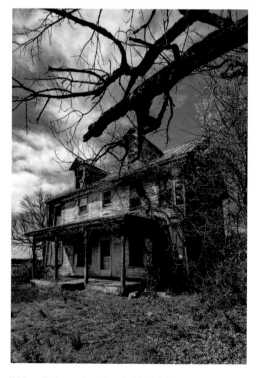

I'd love to know the story behind this house.

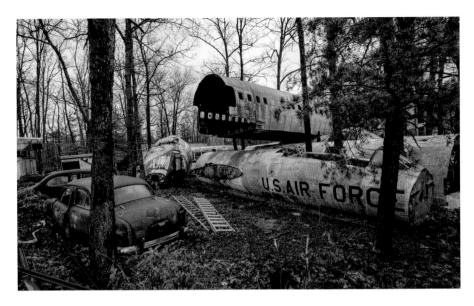

A massive military aircraft left to rot.

The city of Newark is known to be one of New Jersey's more unfortunate cities. Crime and poverty are a major concern for the residents here, so there is no shortage of abandoned sites. This decaying structure was a Gothic Revival gatehouse found at the forgotten Woodland Cemetery. The cemetery fell into disuse in the 1980s, but there are current efforts to restore the cemetery to its former glory.

Down in Cape May, one can find an old World War II bunker rotting away along the Jersey shore. This bunker known as Battery 223, and depending what article you read, it either had two-foot, six-foot, or seven-foot-thick walls. In any case, this massive structure—that was never meant to be permanent—is impressive. Battery 223 was eventually decommissioned in 1944 but did see some use years later. Today, the bunker is park of Cape May State Park and is rumored to be haunted.

This is my most mysterious abandoned boat in all my New Jersey travels. Many locals know this vessel, yet no one can explain its history. This boat is easily found in Ocean County, and hundreds drive past it every day. It seemed the more I tried to research this boat, the more I questioned if it even really existed (even though I have photographed it multiple times). If you look up the location of this boat on Google Maps, it does not appear there. I do enjoy a good mystery.

I think it was no mistake that I discovered an abandoned ship named *Halcyon* at the pandemic peak of New Jersey. New Jersey was hit rather hard by the pandemic and many of us were looking to the past for happier times. When I finally came up on this beautifully decaying ship down the Jersey shore, I felt it was a sign: a sign to stop and appreciate what you have. You never know when you will lose those things you took for granted.

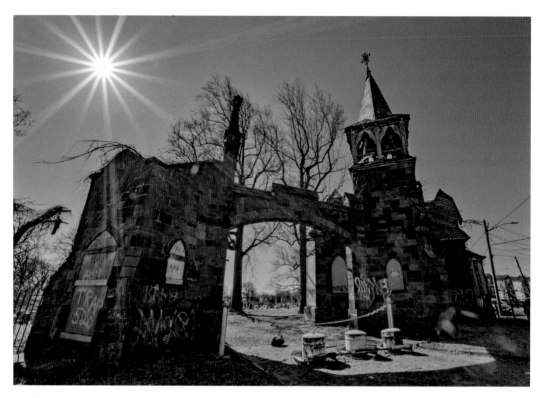

An old gatehouse welcomes you to the abandoned cemetery.

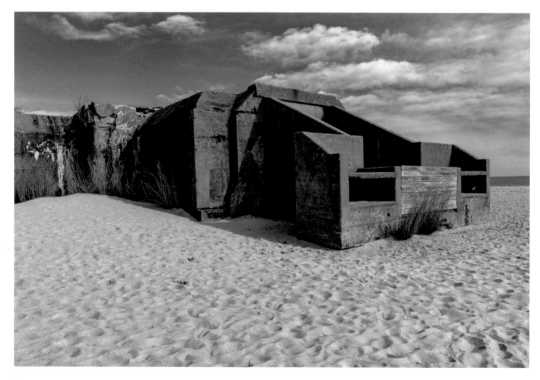

Battery 223 in its sandy grave.

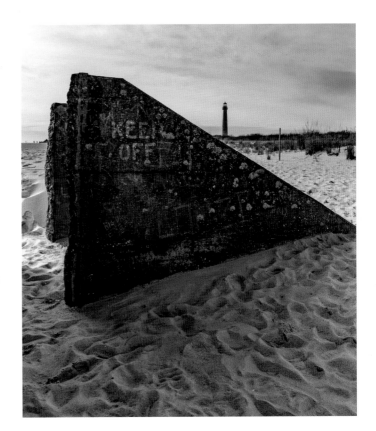

Right: Part of the bunker with the Cape May Lighthouse in the background.

Below left: My mystery ship with a controlled burn in the background.

Below right: An old ship to remind us of better times.

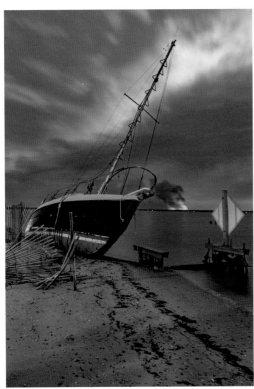

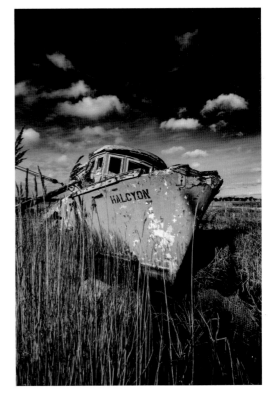

WORKS CITED

abandonedrails.com/Ringoes_to_Lambertville

asylumprojects.org/index.php/New_Jersey_Sanitorium_for_Tuberculosis_Diseases

atlasobscura.com/places/new-jerseys-abandoned-hospitals

atlasobscura.com/places/s-s-atlantus

imdb.com/title/tt3062248/

jerseydigs.com/design-renderings-revealed-380-montgomery-street-jersey-city/

lifeasanomad.com/see-a-crashed-military-jet/

lostdestinations.com/gulick.htm

mycentraljersey.com/story/news/local/development/2018/09/11/bowcraft-scotch-plains-route-
 22-housing-project/1256550002/

mycentraljersey.com/story/news/local/view-from-hillsborough/2017/04/13/the-new-belle-
 mead-station-1919/100420784/

newsbreak.com/new-jersey/andover/municipal/0OSAjv6r/andover-residents-opposed-to-
 proposed-auto-auction-site

nj.com/entertainment/2017/03/dead_pets_and_bucking_broncos_9_strange_sites_uniq.html

nj.com/hudson/2014/11/jersey_citys_st_bridgets_church_being_sold_by_archdioces.html

nj.com/mercer/2011/09/fire_damages_lawrence_historic.html

nj.com/mercer/2015/08/proposals_sought_to_redevelop_neglected_trenton_ch.html

nj.com/news/2019/08/abandoned-sailboat-on-jersey-shore-beach-finally-getting-hauled-off.html

nj.gov/transparency/property/

nj211.org/resource-search/taxonomy/BH-7000.4600-650/_/1

npgallery.nps.gov/GetAsset/cb52e99a-7211-41d1-8426-67c29c3cad25

nytimes.com/2004/05/23/nyregion/dwindling-congregations-churches-once-filled-catholic-
 parishes-jersey-city-are.html

onlyinyourstate.com/new-jersey/abandoned-prison-ruins-nj/

onlyinyourstate.com/new-jersey/nj-abandoned-train-graveyard/

pineypower.com/winslow.htm

pinterest.es/pin/263953228130523353/?nic_v1=1aPO1s44sGxq%2BpwgxoChalAI2NFPDVR
 xmOb5lZedMe58tzMpD8VWYyb%2B8GtTrISpGo

preservationnj.org/listings/belle-mead-station/

preservationnj.org/listings/gulick-house/

pressofatlanticcity.com/news/top_three/flemings-pumpkin-run-in-eht-has-ended/article_
 4d342673-b49a-529e-bb3e-4265716d4ee7.html

publicnoticeads.com/NJ/ search/view.asp? T=PN&id=289%5C7072013_20374573.HTM

publicschoolreview.com/martin-l-king-middle-school-profile/08638

roadsideamerica.com/tip/8513

scoutingny.com/my-memorial-day-searching-for-a-crashed-jet-in-the-nj-woods/

tapatalk.com/groups/theweirdusmessageboard/abandoned-train-restaurant-on-route-46-t3826.
 html

tfpnj.blogspot.com/2018/01/junior-high-school-1-martin-luther-king.html

thetracksidephotographer.com/2016/06/30/ghosts-of-winslow-junction/

wikipedia.org/wiki/Belle_Mead_station

wikipedia.org/wiki/Bowcraft_Amusement_Park

wikipedia.org/wiki/Cornelius_Demarest_House

wikipedia.org/wiki/Essex_County_Jail

wikipedia.org/wiki/Futuro

wikipedia.org/wiki/Newton_Airport_(New_Jersey)

wikipedia.org/wiki/SS_Atlantus

wikipedia.org/wiki/Woodland_Cemetery_(Newark,_New_Jersey)

woodlandcemeterynnj.org/

youtube.com/watch?v=VSdAm-6k60U

ABOUT THE AUTHOR

ALEX GULINO, author of *Empire State of Decay: Discarded New York*, has been exploring ruins and abandoned sites since 2016. Her love of photography began in her teens when her father purchased her first camera, and was later solidified when Alex won her first photography contest for a local newspaper.

While in college, Alex considered majoring in photography; alas, theater arts won out. While she put photography on hold to pursue an acting career, she never forgot her first love. After traveling the U.S. more and more often, Alex noticed many amazing sights that just needed to be photographed. Her first love was reignited, and photography was once again a significant part of her life. Today, Alex travels as often as she can and has discovered a love of abandoned sites. Urbex, a.k.a. urban exploration, has since become a big focus of her photography. See more of Alex's work at www.alexgulino.com or on Instagram @starletlexy.